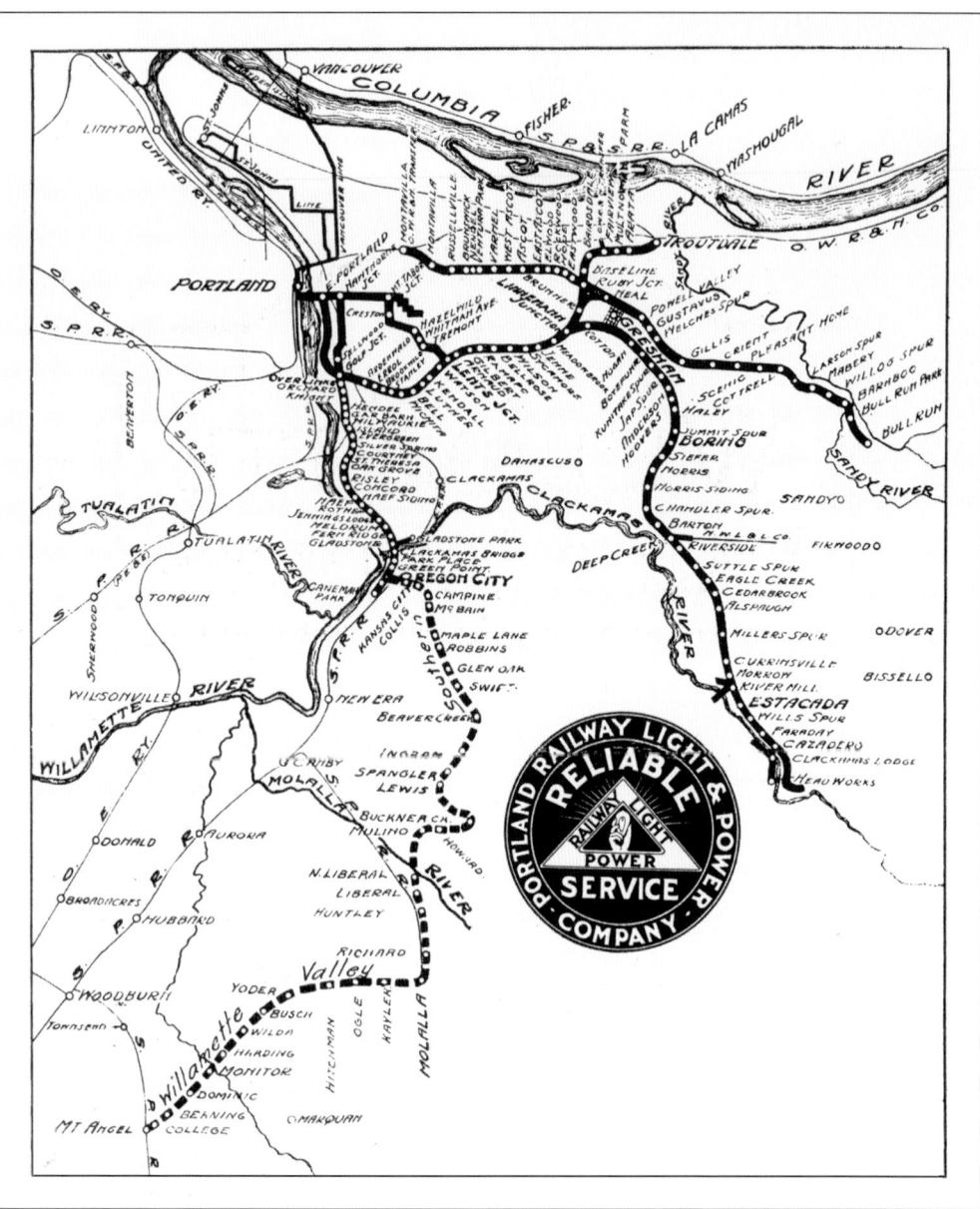

This 1915 map shows the Portland Railway Light and Power Company's interurban lines at their peak. Lines radiating from Portland along the east bank of the Willamette River include Oregon City (30 stops, 14 miles); Bull Run (19 stops, 30.8 miles); Troutdale (6 stations, 21.5 miles); and Estacada (52 stops, 36 miles). The associated Willamette Valley Southern line, then under construction, had 32 stations over 31.9 miles.

ON THE COVER: Salem's first trolley squeals around a corner with dirt streets and plank crosswalks on the Asylum Line *c.* 1891. The large Italianate house in the background is indicative of the rapid development that was taking place. The No. 1 is typical of streetcars of this period, which were single-truck (four-wheel) cars with open platforms. The curved sides gave clearance for horse-drawn wagons to pass. (Courtesy Salem Oregon Public Library, Historic Photograph Collections.)

IMAGES
of Rail

WILLAMETTE VALLEY RAILWAYS

Richard Thompson

ARCADIA
PUBLISHING

Copyright © 2008 by Richard Thompson
ISBN 978-0-7385-5601-7

Published by Arcadia Publishing
Charleston SC, Chicago IL, Portsmouth NH, San Francisco CA

Printed in the United States of America

Library of Congress Catalog Card Number: 2007934170

For all general information contact Arcadia Publishing at:
Telephone 843-853-2070
Fax 843-853-0044
E-mail sales@arcadiapublishing.com
For customer service and orders:
Toll-Free 1-888-313-2665

Visit us on the Internet at www.arcadiapublishing.com

Dedicated to G. Charles "Chuck" Bukowsky (1933–2004), who taught me to love trolleys everywhere.

Contents

Acknowledgments		6
Introduction		7
1.	Portland Area Interurbans (1891–1958)	9
2.	Oregon Electric Railway (1908–1933)	29
3.	United Railways (1911–1923)	49
4.	SP Red Electrics (1914–1929)	59
5.	Willamette Valley Southern (1915–1933)	79
6.	Salem Street Railways (1889–1927)	89
7	Albany Street Railways (1889–1918)	103
8.	Eugene Street Railways (1891–1927)	115

ACKNOWLEDGMENTS

I wish to thank the following individuals for their contribution of images or assistance. Without their help this book would not have been possible: Ed Austin, Bill Binns, Mark Kavanagh, Kenn Lantz, Mark Moore, Tim Muir, Mike Parker, Robert Potts, and Warren Wing. I also consider myself very lucky to have had assistance from my late friends Chuck Bukowsky, Walt Grande, Bill Hayes, Al Haij, and John Labbe.

In addition, I want to thank the following people and institutions for their invaluable help in locating elusive images and information: Tim Backer, Oregon State Archives; Lucy Berkley, Oregon Historical Society; Linda Ellsworth, Linn Genealogical Society; Steve Hallberg, Oregon Historical Society; Gary Halvorson, Oregon State Archives; Winn Herrschaft, Washington County Historical Society; Brian Johnson, City of Portland Archives; Lynette Osborne, Salem Public Library; Cheryl Roffe, Lane County Historical Museum; Tami Sneddon, Albany Regional Museum; and Ross Sutherland, Marion County Historical Society.

I am particularly indebted to my friend Tracy Brown for reading through the manuscript.

If not otherwise noted, images are part of the author's personal collection.

—Richard Martin Thompson

INTRODUCTION

The Cascade Mountains divide Oregon into two regions: high desert to the east and the Willamette Valley and Pacific Coast to the west. The agricultural heart of the state resides in the valley, as do most of its citizens. It was in this region, 150 miles long and up to 60 miles wide, that electric railways reigned from the last decade of the 19th century until the Great Depression.

Oregon joined the rest of the country in a frenzy of interurban electric railroad building. Three new systems, the Oregon Electric (1908), United Railways (1911), and an electrified Southern Pacific (1914), followed in the footsteps of the Portland Railway, Light, and Power Company (PRL&P), whose predecessors had completed the nation's first true interurban line in 1893. Latecomer Willamette Valley Southern joined the fray in 1915 with a predominantly freight line far to the east of its rivals. All but a few of the 432 miles of interurban railway these companies built were concentrated in the Willamette Valley.

The Oregon Electric (OE) and Southern Pacific (SP) built competing lines down the valley from Portland. Trains on the OE's "Willamette Valley Route" climbed the forested slopes surrounding Portland and then sped south through farmland surrounding Salem and Albany on their way to Eugene.

The Southern Pacific Red Electrics ran south from Portland along two routes that joined before reaching the terminus at Corvallis. The West Side Line passed through Beaverton, Hillsboro, and Forest Grove, while the East Side Line traveled via Cook, Newberg, and Saint Joseph.

Relating the attributes of the Oregon Electric and Southern Pacific railways is a bit like comparing apples to oranges. At 122 miles, the OE line between Portland and Eugene was the longest, inspiring the unprecedented convenience of overnight sleeping coaches. Their parlor cars provided reliable, elegant transportation that was second to none.

The Southern Pacific, one of the few electric railroads to use all steel rolling stock, countered with the most modern interurbans in the Northwest. Their 88-mile main line to Corvallis utilized one of the largest 1,500-volt systems in America. As part of a growing network, the SP also managed city streetcar systems in Salem, Albany, Eugene, and West Linn. These systems varied in size from 1 mile to over 35.

The individual characteristics of the five railway companies differed in various ways, but they can all be described as having provided electric interurban passenger and freight service. A real interurban was run according to standard railroad procedure with a mix of regularly scheduled passenger and freight trains, and the interchange of mainline railroad freight. Well-ballasted tracks on private rights-of-way were built to heavy railroad standards, as were the large railroad-style coaches that plied them. A variety of trains and work equipment was dispatched over interurban roads, ranging from crack expresses, to workaday freight trains pulled by electric locomotives. They often passed well-tended stations whose picturesque architecture resembled a family home more than a part of the transportation infrastructure.

Like interurbans elsewhere, most electric railways in Oregon enjoyed a brief lifetime. Their coming had been heralded with speeches and fanfare, yet abandonment occurred with scarcely

a comment. During the 1920s, highway improvement and the growth of automobile ownership led to decreasing ridership. Passenger service was dropped on all but two of Oregon's interurban railways. The Oregon Electric soldiered on until 1933, and then there was one.

Oregon's first interurban would also be its last. PRL&P's successor, the Portland Traction Company, operated lines to Oregon City and Bell Rose until 1958, by which time they had provided passenger service longer than any other electric railway in America. Their last interurbans had come to resemble the streetcars that plied city streets in both appearance and operation.

Today electric ghosts haunt the rails of systems whose lives were cut short. Only a few crumbling substations and passenger stations converted into restaurants remain as vestiges of Oregon's interurban past. The musical wail of brass air horns and the thump-thump-thump of air compressors are heard only in museums. It is left for historic images like those in this book to provide a sense of what it was like to travel through the beautiful Willamette Valley during the interurban age and to help define the electric railway experience for new generations.

One

PORTLAND AREA INTERURBANS (1891–1958)

The Portland area is generally credited with having the country's first true interurban railway. Electric railways had connected cities elsewhere, but the line between Portland and Oregon City was the first electric railroad designed to accommodate passengers, baggage, mail, and freight. It was also the first railway to regularly interchange freight with main line railroads and the first to use electricity transmitted over long distances from a hydroelectric dam.

The Portland Railway, Light, and Power Company (PRL&P) and its predecessor and succeeding companies operated interurban passenger and freight train service in Multnomah and Clackamas Counties from 1891 to 1958. This was 15 years before—and 25 years after—other electric interurban railways in Oregon.

In the early years of the 20th century, as other railway companies began building lines south to Eugene and Corvallis, or westward to Hillsboro and Forest Grove, the region east of the Willamette River was left mainly to Portland's street railway company. Two principal routes were developed to the south and east. The first of these was the pioneering 14-mile line to Oregon City completed by the East Side Railway on February 16, 1893. In 1903, the Oregon Water Power and Railway Company (OWP) inaugurated service on a 36-mile-long southeasterly route to Cazadero. After PRL&P consolidated all streetcar and interurban lines in 1906, extensions were built to Troutdale and Bull Run.

In 1927, the new Portland Electric Power Company (PEPCO) began abandoning marginal lines, including Troutdale (1927), Cazadero (1933), Boring (1936), and Gresham (1949). The railroad was sold to a California-based company in 1946, which separated the city and interurban systems. The interurban lines became the Portland Railroad and Terminal Division of the Portland Traction Company (PTC). In 1956, PTC allowed Multnomah County to build new Hawthorne Bridge ramps without tracks. Ridership fell drastically. On January 25, 1958, passenger service was abruptly terminated in violation of Public Utility Commission (PUC) orders.

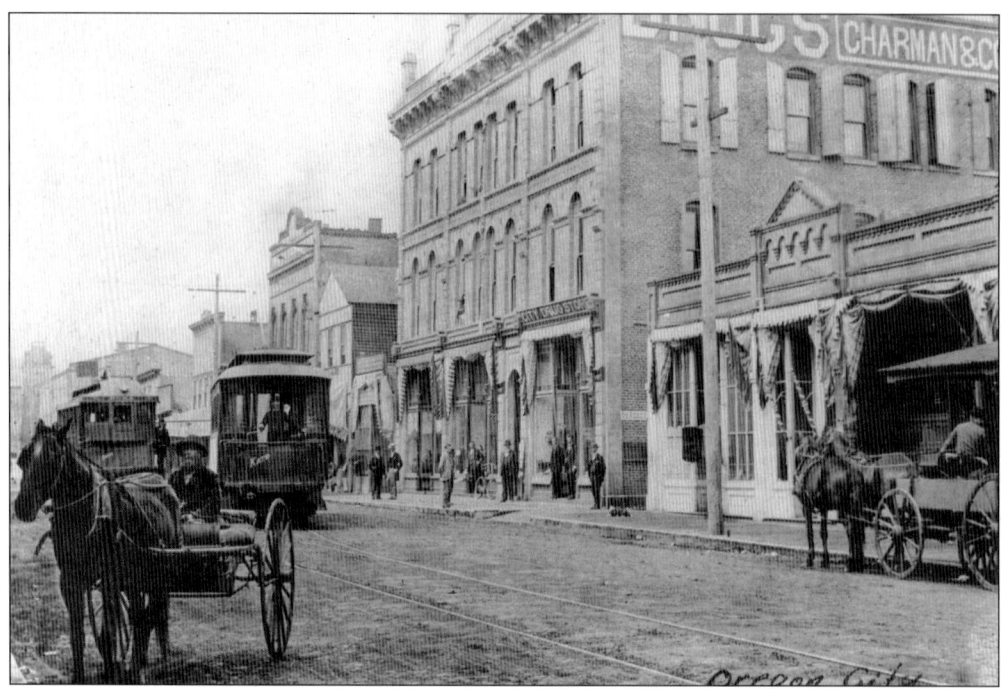

East Side Railway cars Bona and Kate are seen near the southern terminus of the line on Main Street in Oregon City during the 1890s. The nation's first true electric railroad named its cars like ships rather than numbering them. The Bona was a locally built Columbia Car and Tool convertible, while the Kate was a product of the Pullman Palace Car Company.

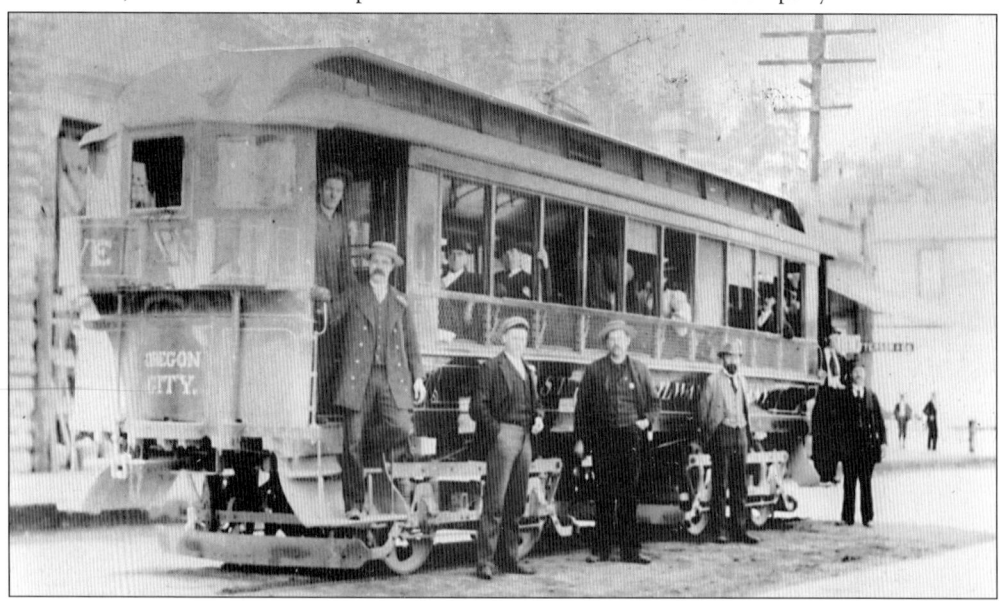

Passengers and crew pose with the East Side Railway's Eve in Oregon City soon after completion of the 14-mile line in 1893. The Eve was a new double-truck semi-convertible built by the J. G. Brill Company of Philadelphia. Platforms had been equipped with removable bay-window enclosures and screening placed along the bottom of the open windows to keep people from leaning out or falling.

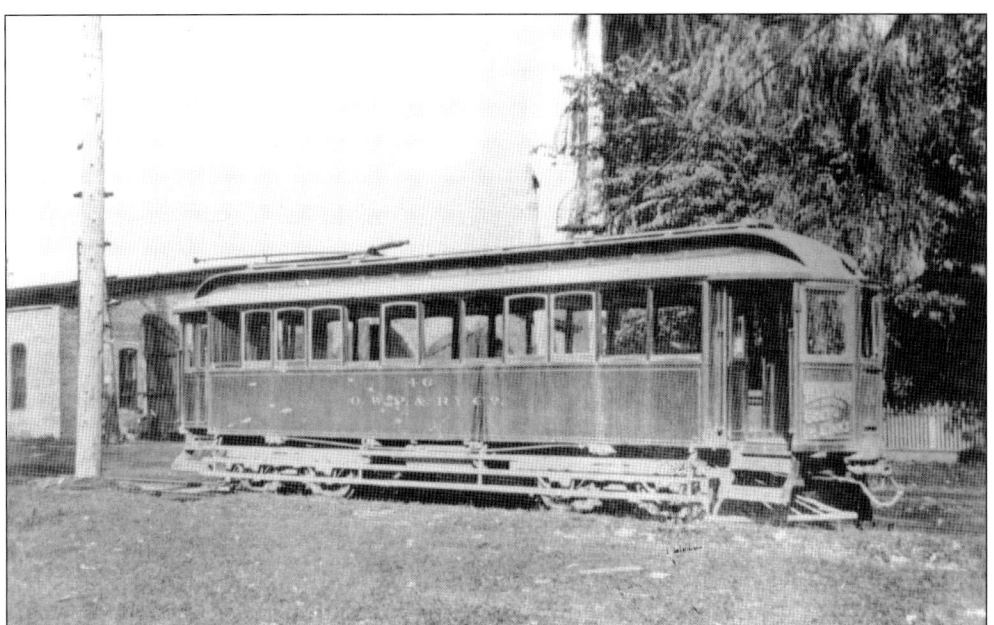

OWP car No. 46 rests in front of the Milwaukie carbarn on a warm day at the beginning of the 20th century. No. 46 is thought to have been built by the Indianapolis Car Company for the East Side Railway in 1891. It had undergone extensive remodeling by its OWP days. The elaborate dash sign reads, "Sellwood and Golf Links." The golf course referred to in the sign became Waverly Country Club.

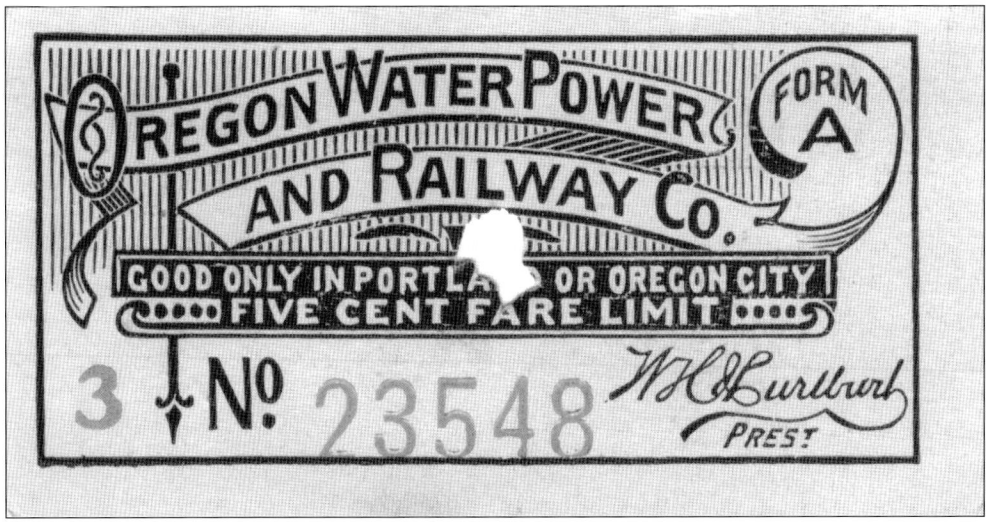

This undated Oregon Water Power and Railway Company ticket was good only in Portland or Oregon City. The OWP was incorporated on June 6, 1902, and was soon operating the former East Side Railway interurban line to Oregon City, as well as the standard-gauge Hawthorne, Mount Scott, and Sellwood lines in Portland. Interurban extensions were built to Gresham in 1903, Cazadero in 1904, and Troutdale in 1908.

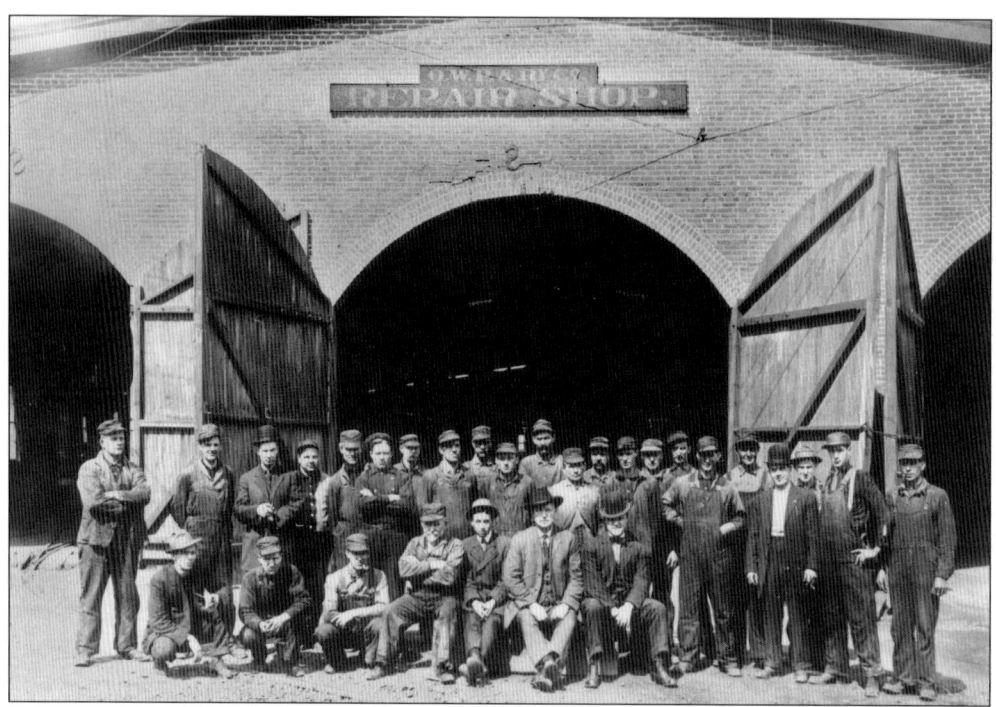

Everyone at the Milwaukie shops posed for this one. The East Side Railway reached Milwaukie in August 1892 and began building shops on a half-block of land at the north end of town. In 1909, the facility that housed the nation's first interurban cars was replaced by the new Sellwood car house. (Photograph taken by Fred L. Blaisdell.)

Motor No. 62 is still wearing OWP numbers at Oregon City in 1912. Mustachioed motorman Leon M. Fernandez is standing beside the extra flag at the front of the car. Next to the mills in the background are two more interurbans and an open 1200-series trailer. Note the pilot (cowcatcher) under the lead car and the side slats (designed to keep children and animals from running underneath) on the trailing car.

This view at Southeast Thirteenth Avenue and Ochoco Street shows the Golf Links station and the Oregon Water Power and Railway substation in 1907 after OWP was merged into the PRL&P. In 1909, the Sellwood carbarn would be constructed on the land immediately behind this station. The station was renamed Golf Junction and was relocated to the other side of the tracks.

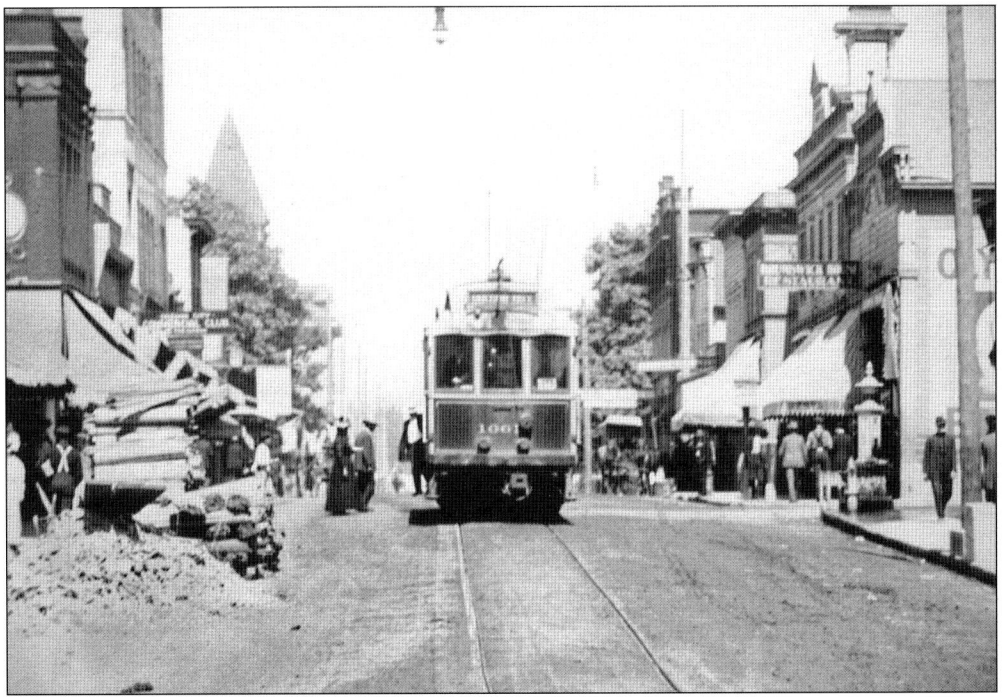

Car No. 1001 is seen traveling toward the southern terminus of the line in downtown Oregon City during the early PRL&P years. Portland, Oak Grove, Gladstone, and Oregon City offered plenty of middle-of-the-street running. There were 28 stops between Golf Junction and the end of the line in Oregon City.

13

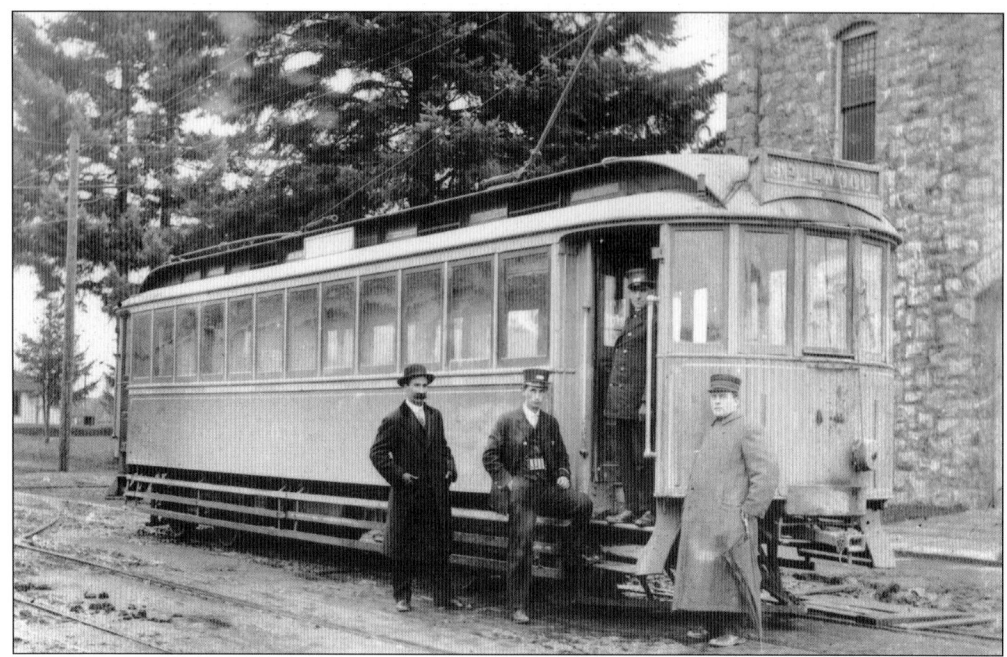

Several carmen have gathered next to No. 1031 as ends are changed at the Southeast Thirteenth Avenue and Ochoco Street terminus of the Sellwood line. The OWP substation is in background. No. 1031 was a 41-foot standard-gauge interurban that was primarily used in Sellwood service. It was ordered c. 1901 for OWP predecessor Portland City and Oregon Railway and remained in service until 1933. (Courtesy Mark Moore.)

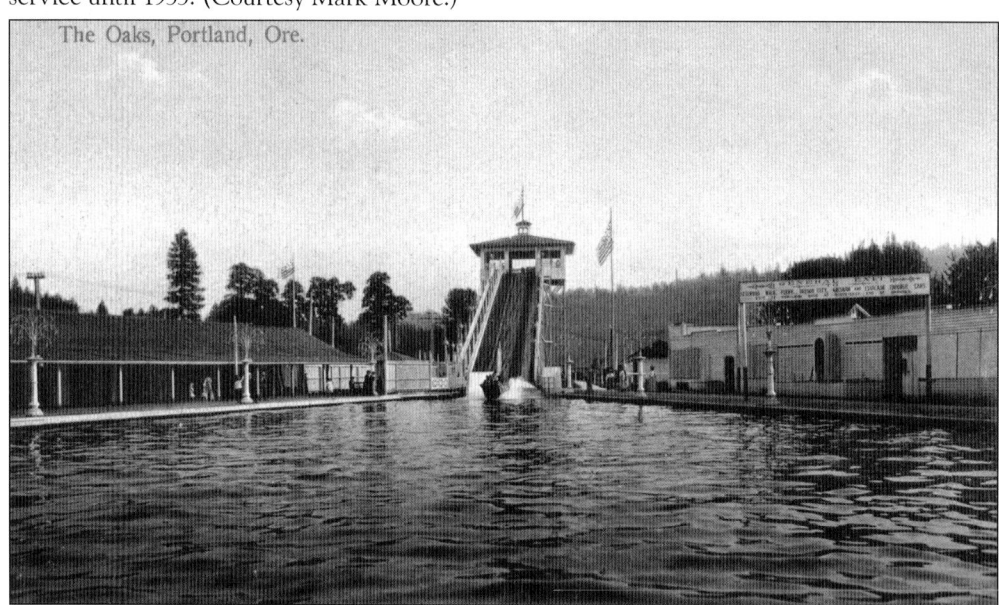

OWP opened a 44-acre amusement park on the east bank of the Willamette River in 1905. The Oaks was a classic trolley park designed to increase ticket sales during evenings and weekends, when the trolleys carried fewer passengers. The park drew an average of 300,000 visitors a month to picnic, listen to band music, swim, or enjoy rides, such as the "Water Chutes" (pictured). Oaks Park is in operation to this day.

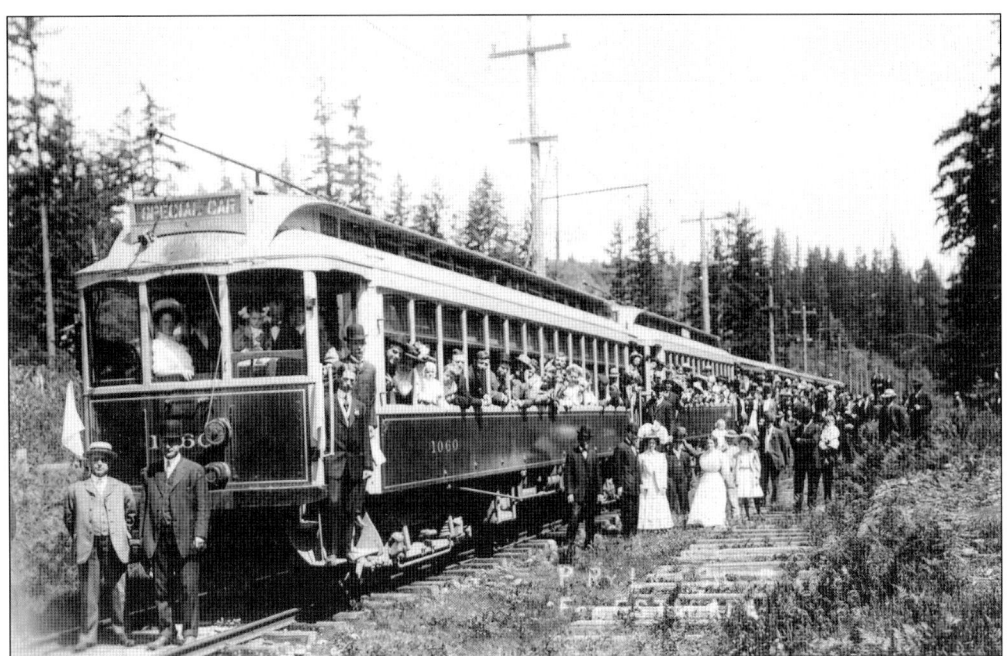

Extra No. 1060 heads a seven-car excursion train near the end-of-rail on the Estacada line. The crowd is dressed in their Sunday finest, and it is a good day for a picnic. The two 1904 vintage Brills are filled to capacity, which was 56 passengers each, not including standees. (Courtesy Mark Moore.)

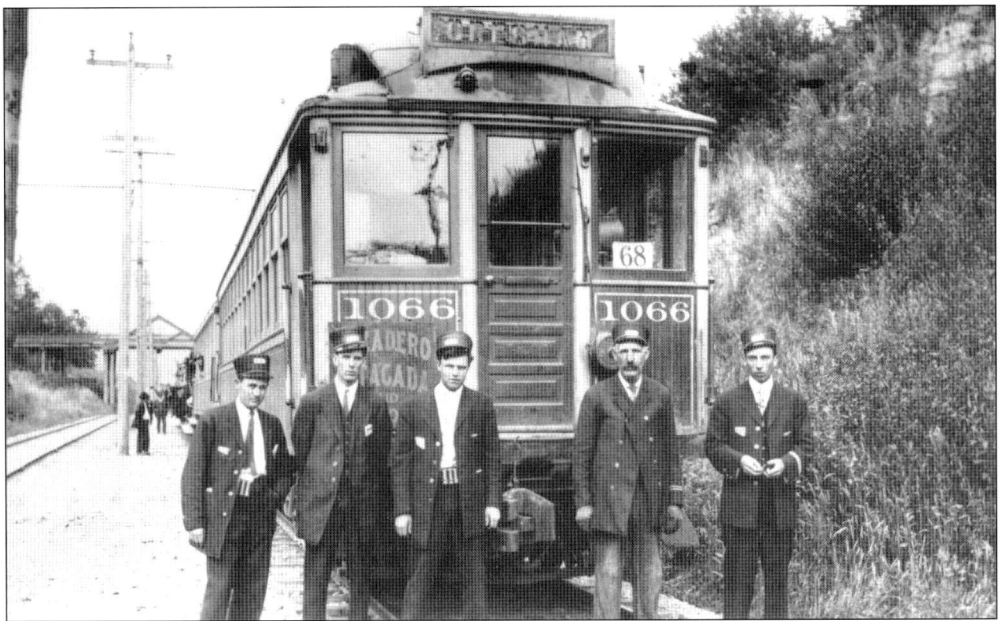

The motley crew of train No. 68 watches the birdie at an unidentified location on the Gresham line. From left to right are Glen Durham, unidentified, Bert Million, Motorman Robert "Dad" Walker, and H. S. Frick. No. 1066 was a Brill trailer remodeled in the PRL&P shops about 1907. In several ways, this handsome design set the pattern for later cars. Note the wood truss bridge in the background.

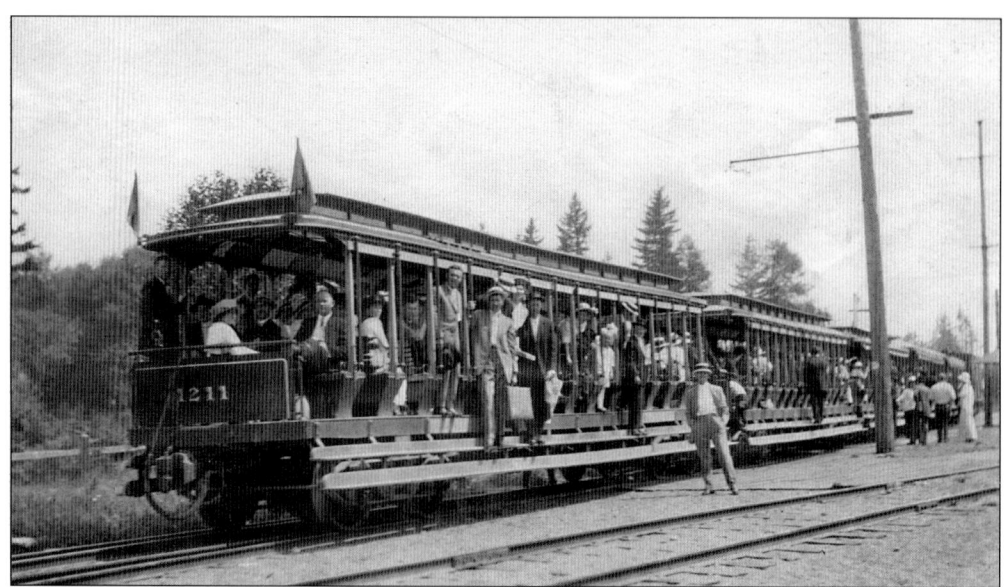

The happy excursionists in this undated scene are aboard a five-car extra train pulled by a box-motor freight locomotive. The location appears to be Linneman Junction on the Springwater Division. The cars are all open trailers, including two class 1211–1213, ex–East Side Railway cars built by Holman in 1893 and three class 1275–1295 cars built by OWP around 1905. Look at all the straw hats.

Milwaukie station provides a number of extra services in this 1915 view. Between the waiting room and ticket office is a store selling candy, soda, ice cream, and tobacco. In the window behind the two gentlemen are campaign posters for sheriff. The circular sign above them reads, "Voters register here." The sign on the telephone pole advises, "Take cars here." (Photograph taken by Fred L. Blaisdell.)

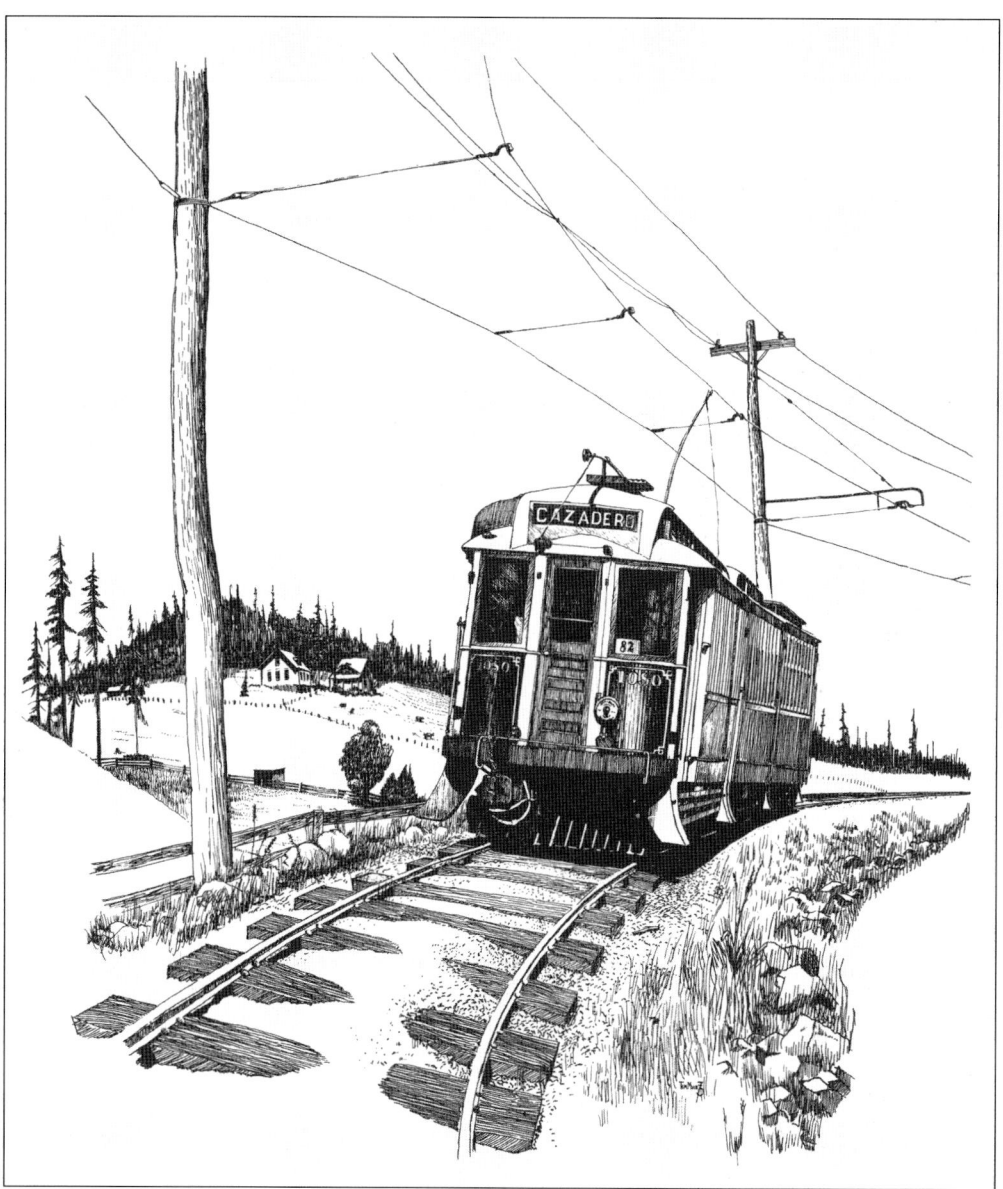

PRL&P Springwater Division combine No. 1050 is traveling through open country on the Cazadero line. Oregon Water Power ordered the car from the Holman Car Company of San Francisco in 1893. It was originally No. 50. PRL&P added train doors and converted the freight compartment into a smoking section. No. 1050 was retired in 1936. This sketch was drawn by artist Tim Muir. (Courtesy Tim Muir.)

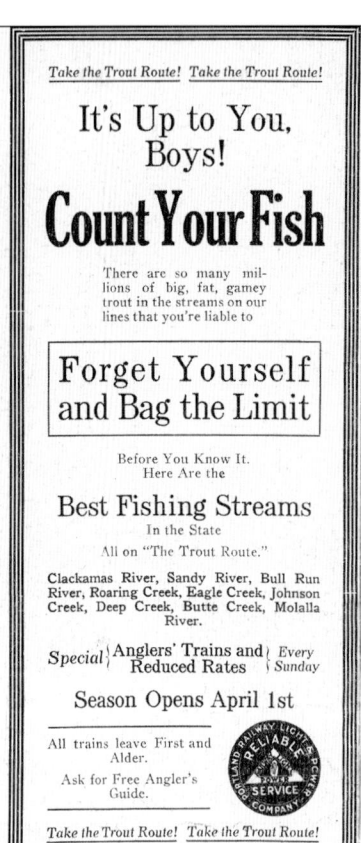

This advertisement from the March 30, 1915, *Evening Telegram* encourages sportsmen to "Take the Trout Route." The best fishing streams are described as being on rivers and creeks along the Estacada line. Special reduced-rate anglers' trains would begin running at the beginning of April. The distinctive PRL&P logo in the right corner incorporated rays of light radiating from a light bulb inside a triangle labeled "Railway, Light, Power."

In 1909, PRL&P rebuilt Niles interurban No. 1057 as the private parlor car Portland. It became the corporate flagship and was used for executive inspection trips or leased for parties. The car is seen here with its crew in the East Portland yard. It was retired in 1937. Note the brass-railed observation platform and the illuminated PRL&P drumhead.

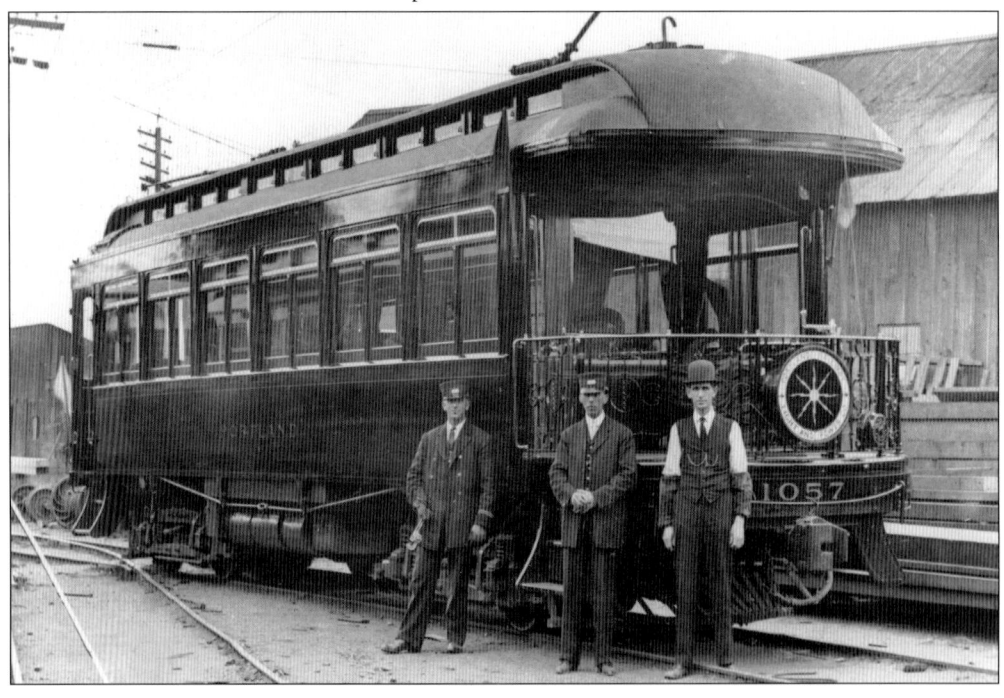

A crewman relaxes in the richly appointed interior of the Portland. The car featured plush, upholstered, wicker armchairs, heavy drapes, antiqued brass lights, and carpeted floors. The controller on the observation platform allowed the car to be operated from the back when needed.

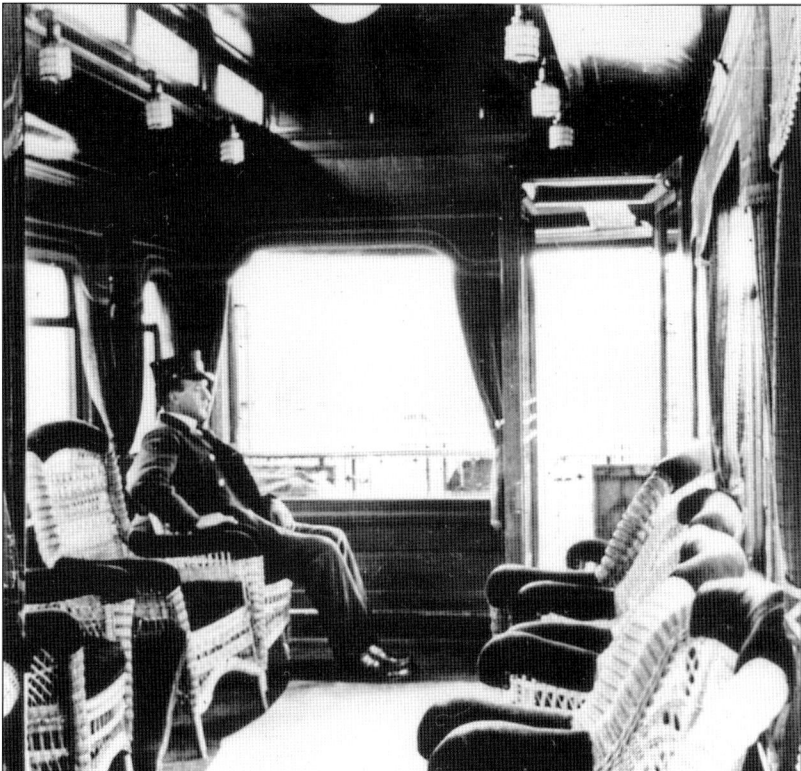

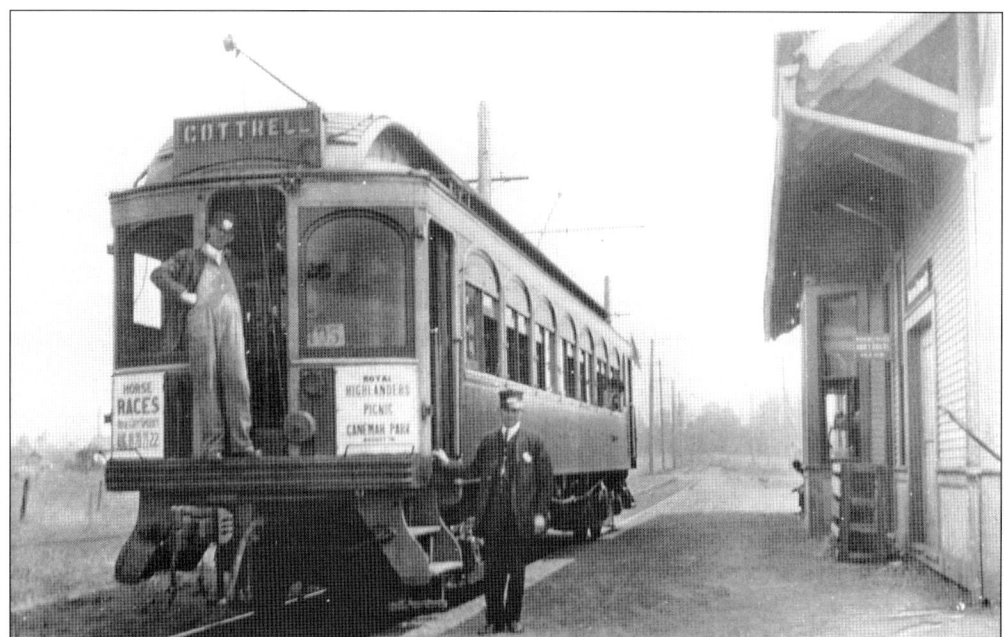

Train No. 495 is seen at Gresham on its way to Cottrell during the 1910s. Cottrell was the point on the Bull Run line from which the original plan was to build on to Sandy and Mount Hood. The plan was dropped after PRL&P took over. The Kuhlman interurbans in this series were renumbered 1124–1127 by PRL&P. (Courtesy Mark Moore.)

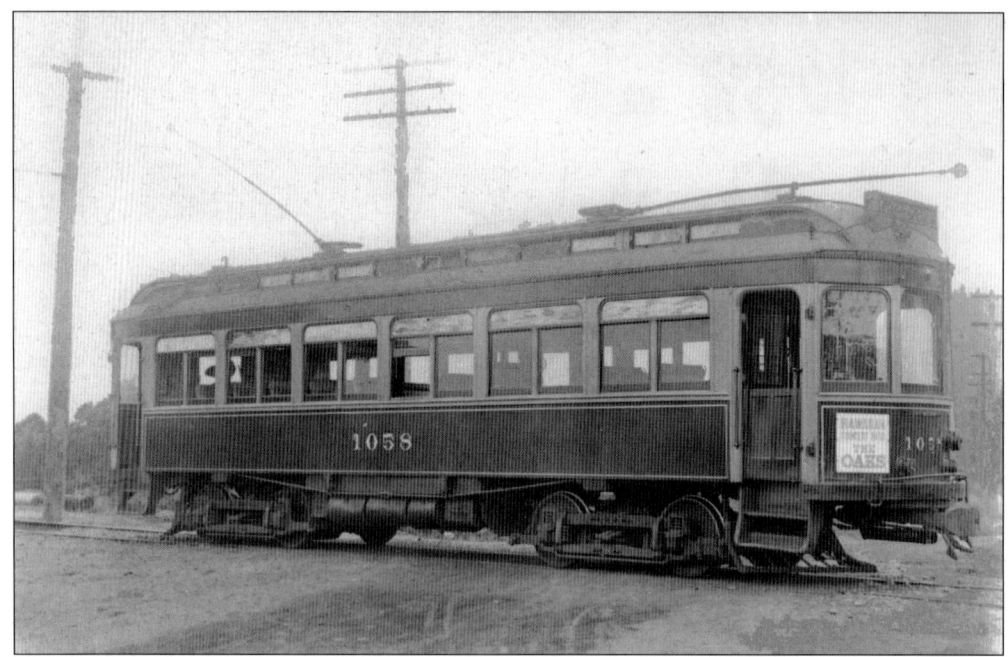

PRL&P used former OWP No. 58 on Troutdale shuttle service. The Niles-built interurban proudly exhibits its large sightseeing windows with colored-glass panels in this 1910 photograph at Troutdale. No. 1058 suffered a worse fate than sister car No. 1057; it was remodeled as a line car in 1930, emerging from the shops with a tower on the roof and bins in its once-elegant interior.

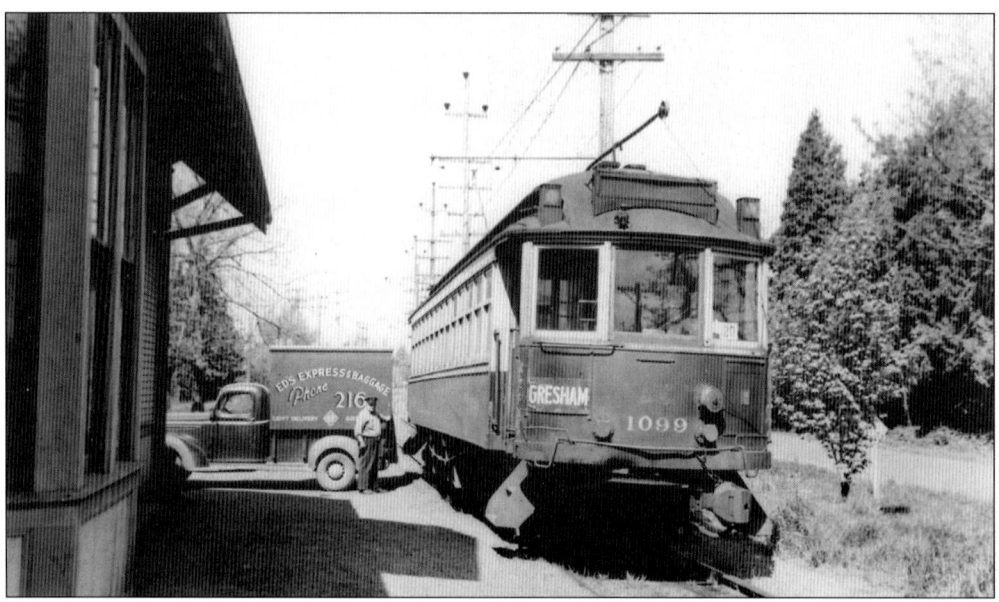

No. 1099 is loading packages at the old Mount Hood Division Station in Gresham during the 1940s. The locally built 1090-class cars were rather plain in comparison with other interurbans, with no colored glass, upholstered seats, or fancy woodwork. Until Portland Traction began experimenting with other paint schemes, the 1090s were painted in attractive maroon and cream colors. (Courtesy Mark Moore.)

This mouse-eye view inside Portland Traction Company interurban No. 1097 looks past the Hale and Kilburn walkover rattan seats into the vestibule. On the motorman's platform are a GE K-6 controller and Westinghouse airbrake and gauges. The large black switch marked "on" and "off" on the ceiling is a GE automatic circuit breaker. (Photograph taken by Mike Parker.)

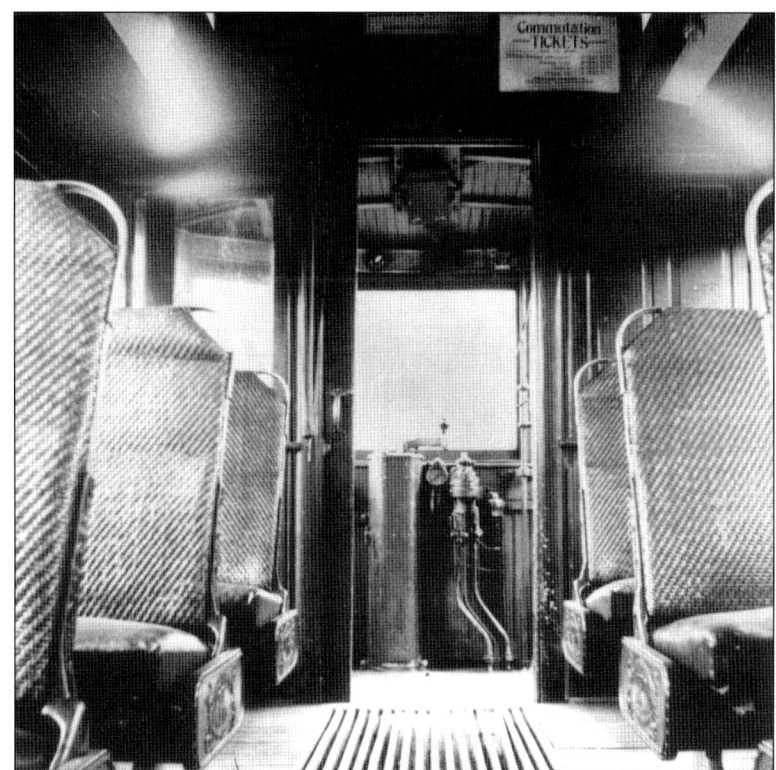

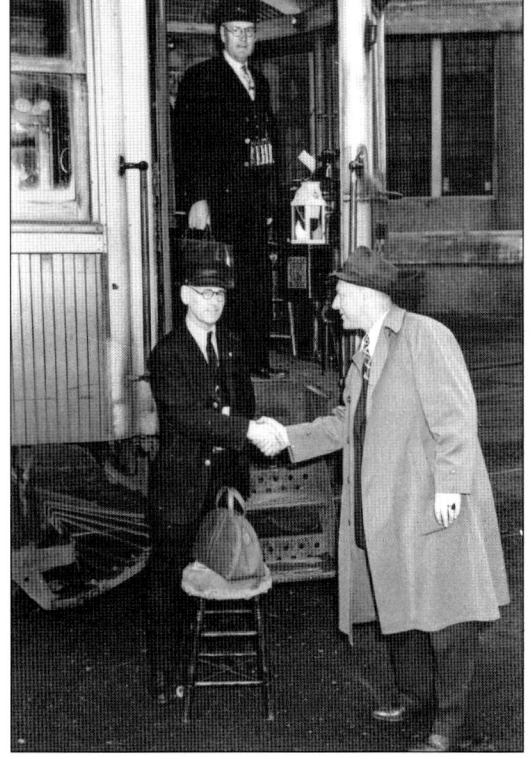

PTC superintendent Edward Vonderahe is shaking hands with retiring motorman Fred H. Wallace during a crew change in front of the Hawthorne Building. Both operators are wearing old-style uniforms and are carrying their own stools. Wallace was usually assigned No. 1097 for his nightly run on the Bell Rose owl. By 1954, all wooden cars had been replaced with more modern equipment that Vonderahe located on buying trips across the country.

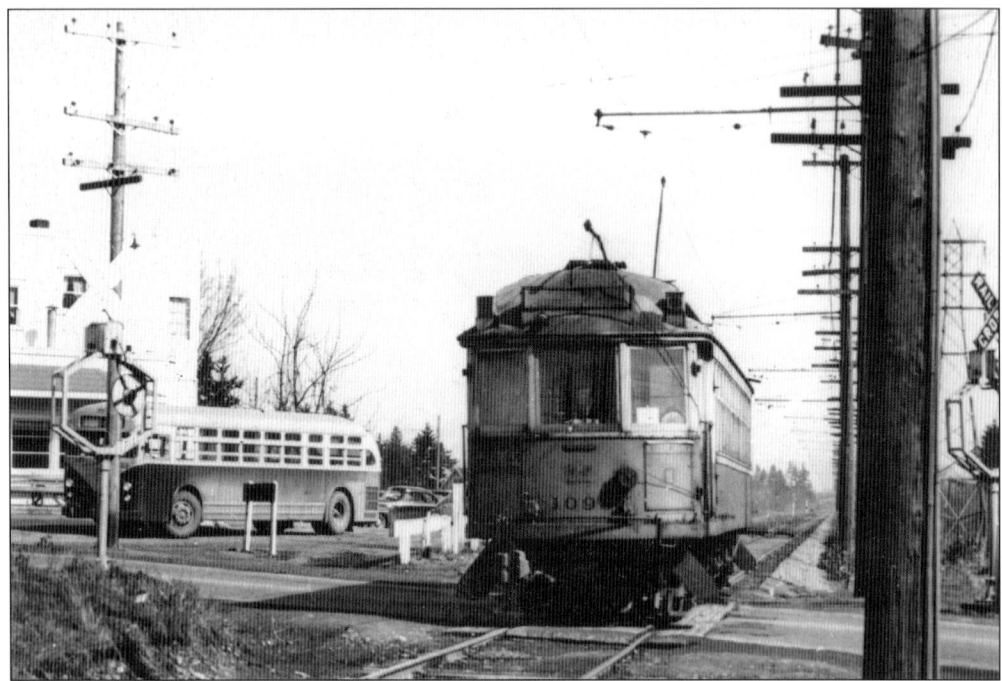

Outbound Bell Rose car No. 1093 sails past the wigwag signal at Southeast Eighty-second Avenue in March 1949. In the background, in front of Kendall Station is a 900-series Mack bus working the Powell Boulevard line. No. 1093 is wearing orange livery with cream trim.

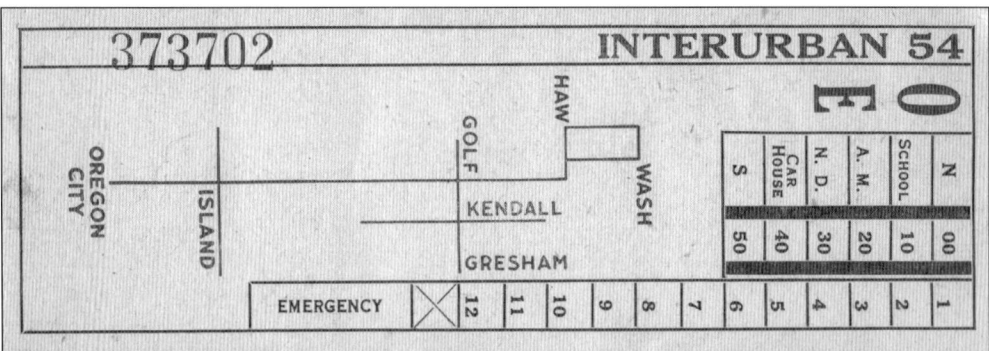

This Portland Traction Company transfer is for interurban train No. 54, the Bell Rose Daily, which departed Portland at 8:50 p.m. and reached Bell Rose at 9:26 p.m. It was issued before the line was cut back from the Mount Hood Depot in Gresham in 1949. The map shows the downtown interurban loop, as well as main transfer points on the Oregon City and Gresham lines.

22

This snapshot outside the downtown interurban terminal at Southwest First Avenue and Washington Street in Portland was taken during the 1950s. The classic neon sign reads, "Take Interurban cars here for Oaks Amusement Park, Bell Rose, Oregon City." Those who remember riding the trolleys recall the sign as having white, red, and yellow letters.

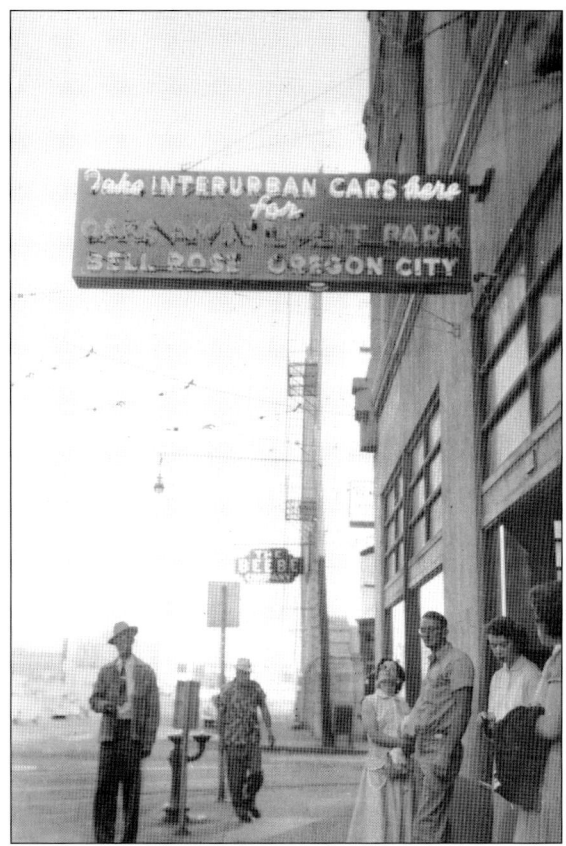

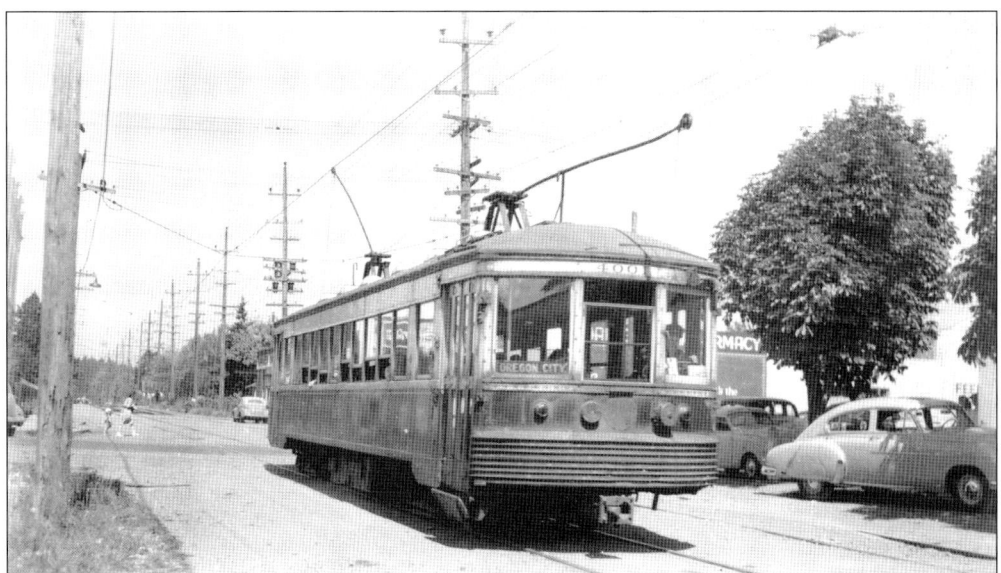

During the 1940s, PEPCO began supplementing its aging interurban fleet with secondhand steel rolling stock. The initial group, Nos. 4000–4005, came from the Indiana Railroad in 1940. Indiana No. 4001 is seen here passing through Oak Grove on the way to Oregon City in the mid-1950s. Successor Portland Traction Company continued the replacement effort.

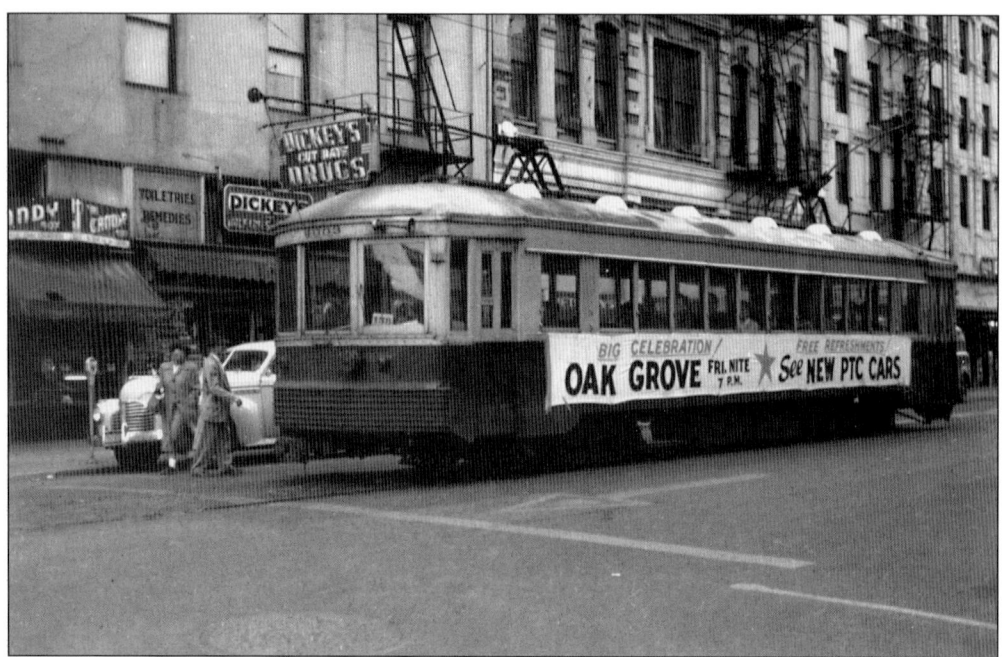

PTC No. 4003 stops to pick up passengers at Southwest First Avenue and Washington Street in 1953. The large banner on the side promoted an Oak Grove celebration for the arrival of "New PTC cars." The cars referred to were eight ex–Pacific Electric "Hollywood" cars.

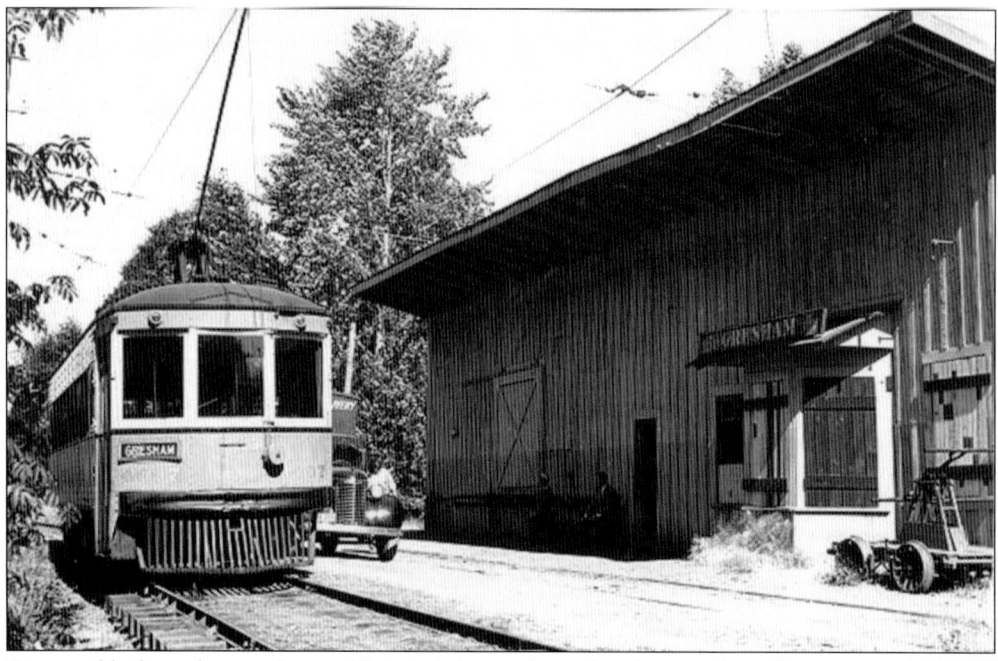

Orange, black, and cream liveried No. 4007 is eastbound at the Gresham Springwater Division Station in the 1940s. The curved-side lightweight car was a 1925 product of the Cincinnati Car Company. Portland Traction bought Nos. 4006 and 4007 from the Fonda, Johnstown, and Gloversville Railway in New York. They had a smaller seating capacity than other interurbans and were generally used on the Gresham (later Bell Rose) line. (Courtesy Mark Moore.)

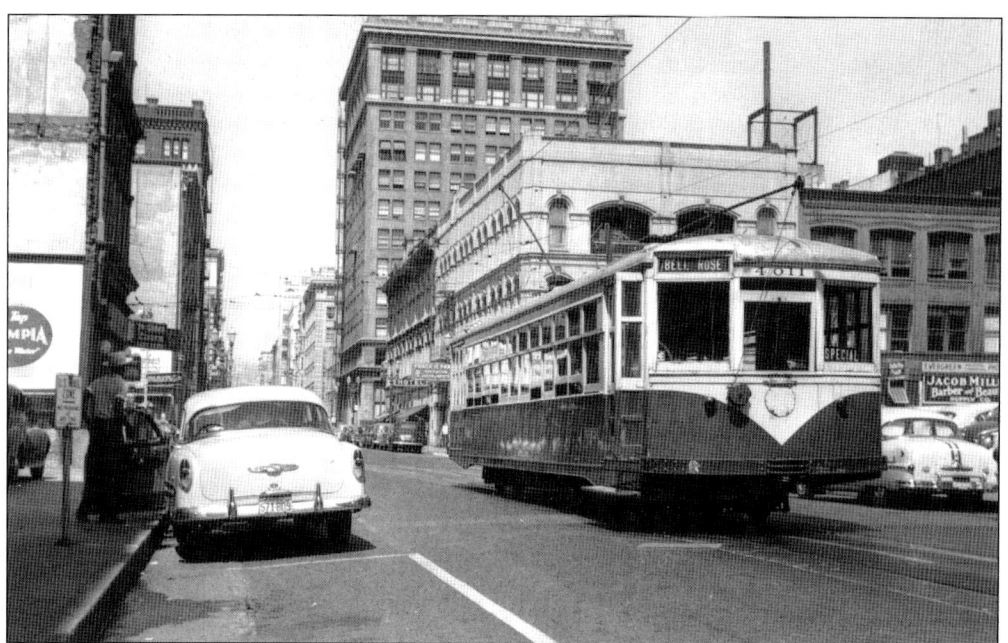

Portland Traction Company No. 4011, seen here at the First Avenue and Washington Street interurban station in Portland, was on loan from the California Railroad Museum from 1949 until the close of service in 1958. The car was then returned to the museum at Rio Vista Junction and repainted in its original Key System colors. It was built by Key System Transit in their Emeryville shops in 1926.

Two Broadway cars were rebuilt as standard-gauge interurbans in 1950. No. 813 received running gear from wrecked Indiana car No. 4000, becoming No. 4012. It operated successfully until the end of service and is preserved today by the Oregon Electric Railway Historical Society in Brooks. No. 800, seen here in snowy East Portland, became No. 4014. It was scrapped in 1954. Ironically, these two cars were the newest in the interurban division.

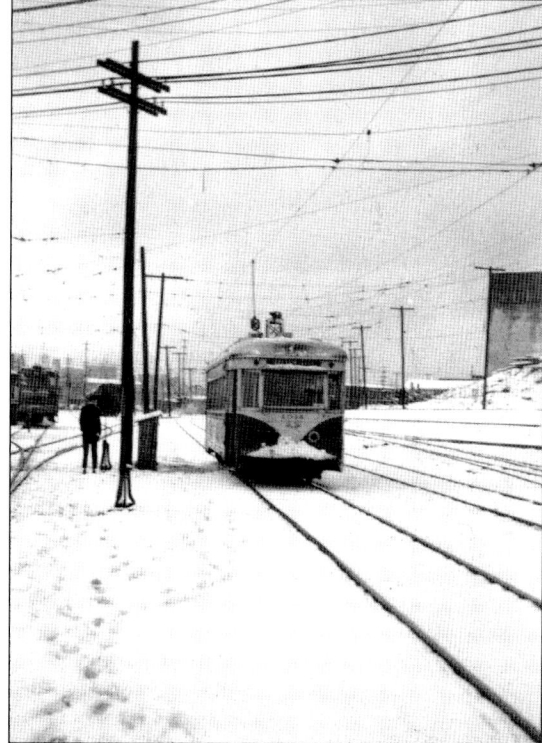

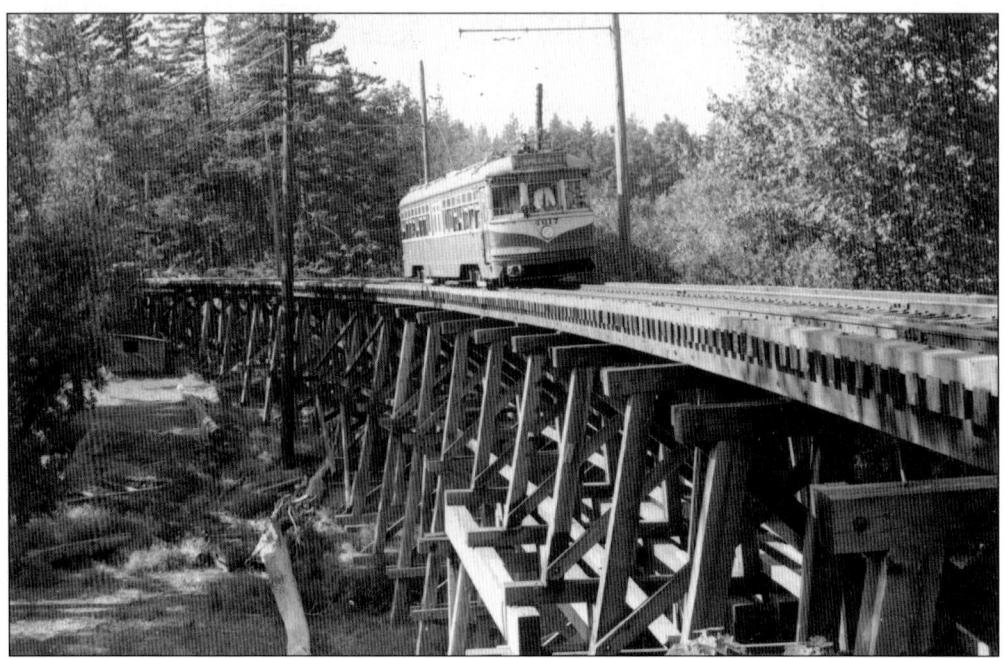

Portland Traction "Hollywood" car No. 4017 rumbles southward across the Milwaukie Trestle in 1955. The last group of secondhand cars, Nos. 4015–4022, arrived from the Pacific Electric in 1953. These 52-foot-long suburban cars were geared for a maximum speed of 45 miles per hour.

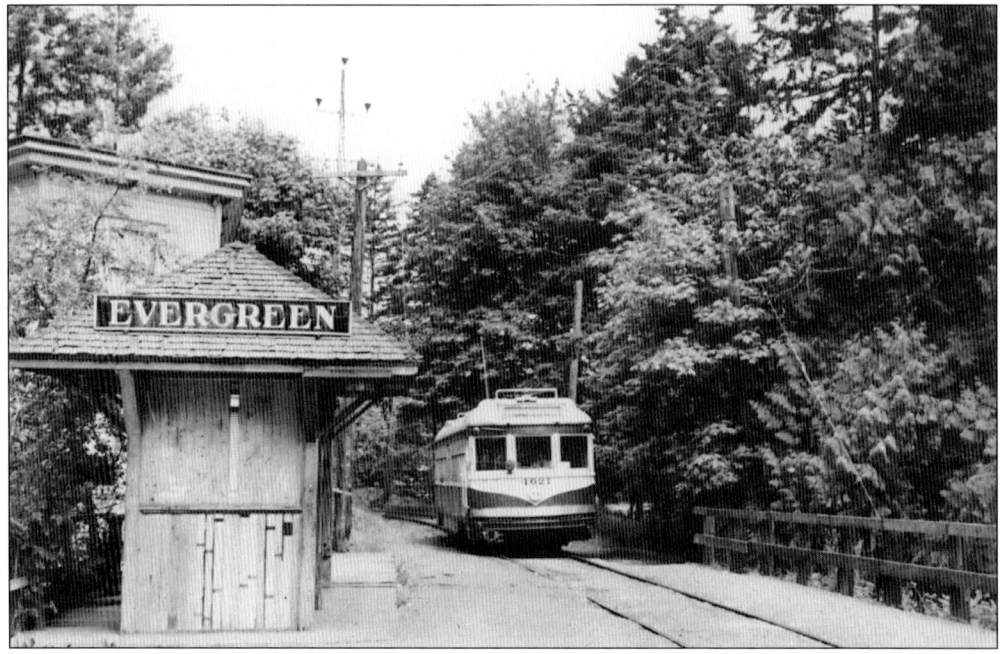

Outbound Oregon City car No. 4021 is gliding to a stop at Evergreen Station during the 1950s. PTC stations were simple, three-walled waiting rooms facing the tracks. The author remembers these structures well, since he and his grandmother caught the cars one stop north of here at Island. They were painted gray, and they had a single light fixture in the ceiling and large black signs with white letters.

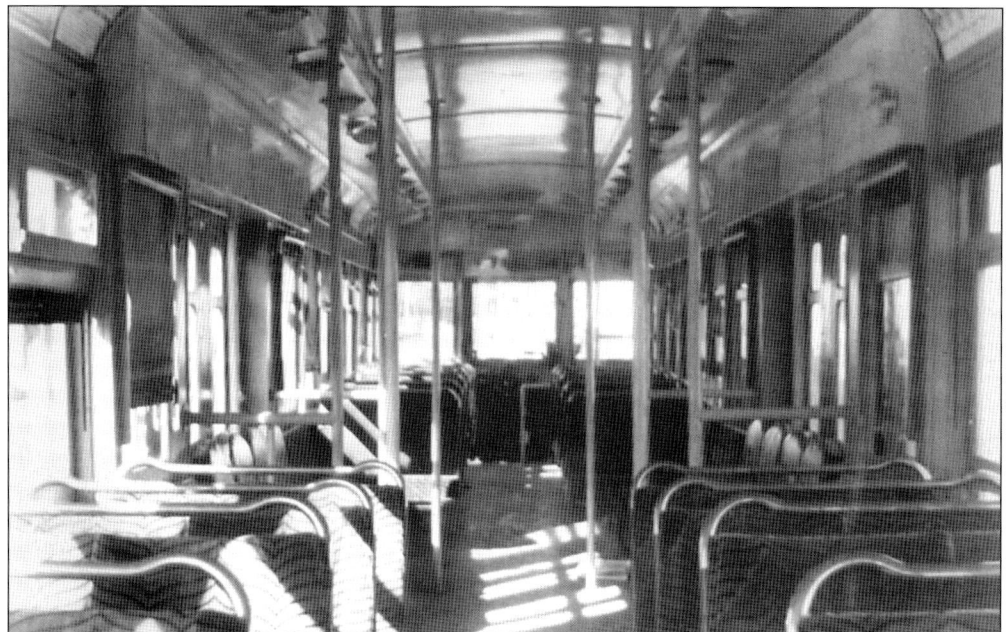

Eight former Pacific Electric lightweights were brought to Portland in 1953. Although new to Portland, the Hollywoods were built in 1924 by the St. Louis Car Company. Their memorable gray-green-and-charcoal plush upholstery was quite a contrast to the rattan or leather seating found on other cars. Longitudinal seats have been placed in front of the permanently closed drop-center entrances.

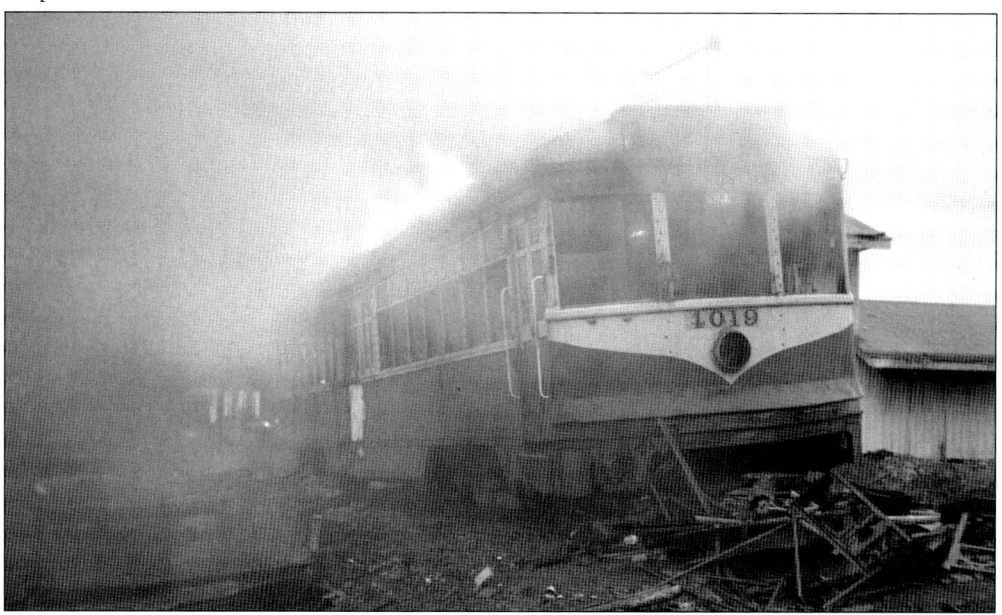

No. 4019 succumbed to the scrapper's torch in March 1959. Half of the 16 secondhand cars still in service in 1958 were spared a similar fate. Nos. 4001 and 4011 went to the Bay Area museum; No. 4012 is preserved by the Oregon Electric Railway Historical Society, Nos. 4003, 4009, and 4010 went to collectors in Washington, and No. 4022 ended up with an Oregon collector. (Photograph taken by Tracy B. Brown.)

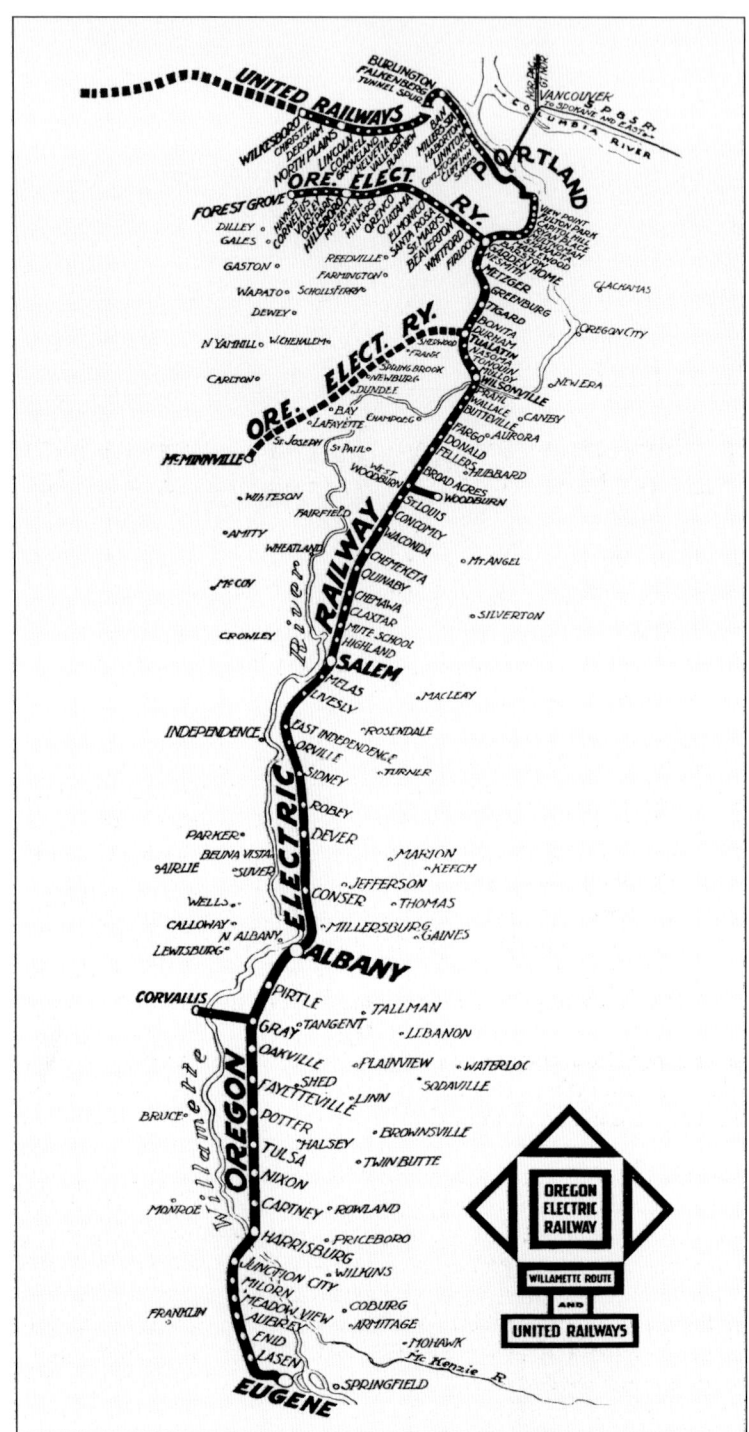

This c. 1920 map of the Oregon Electric Railway system shows the 120-mile Willamette Route to Eugene, as well as branch lines to Forest Grove and Corvallis, and the United Railways (UR) line to Wilkesboro. The projected OE branch to McMinnville (dashed lines) was not built. The projected UR extension beyond Wilkesboro went no farther than Banks.

Two

OREGON ELECTRIC RAILWAY (1908–1933)

On May 14, 1906, Thomas S. Brooks, Henry L. Corbett, and R. W. Lewis, backed by East Coast capital, formed the Oregon Electric Railway (OE). Its stated purpose was to construct an electric railroad south through the Willamette Valley from Portland to Roseburg. Portland street railway and bridge builder Charles F. Swigert would become president.

The first trains began operating between Portland and Salem on New Year's Day 1908. Branch lines were quickly added to Forest Grove in 1908 and to Woodburn in 1909. On October 17, 1912, the main line reached Eugene, which would turn out to be the road's southernmost terminus. On March 25 of the following year, a final branch went into service between Albany and Corvallis.

OE rolling stock ranged from combination baggage, smoking, and passenger motors, to observation parlor cars and unique interurban sleepers. The fleet's colors changed from bright traction orange to a more conservative dark green after the OE became part of James J. Hill's railroad empire in 1910.

Although the OE's 122-mile route through the Willamette Valley was the longest for any electric railway in the state, much of the company's business came from the Portland suburbs. A dozen trains a day were dispatched to serve commuters, students, and shoppers in Hillsboro, Forest Grove, Beaverton, Wilsonville, Tualatin, and Tigard. Four or five trains a day ran through to Eugene. On weekends, popular reduced-fare excursions operated between Portland and Salem.

Initial operating costs were reasonable for an interurban, but when passenger volume did not develop as expected, reductions in service were made. Competition from automobiles, trucks, and buses steadily eroded revenue after the peak year in 1920. The end came during the Great Depression. Branch operations were cut to Corvallis in 1931 and to Forest Grove in 1932. All passenger service ceased May 13, 1933, although electric locomotives provided motive power until July 10, 1945. The Oregon Electric Railway survived as a diesel freight railroad into the 1990s.

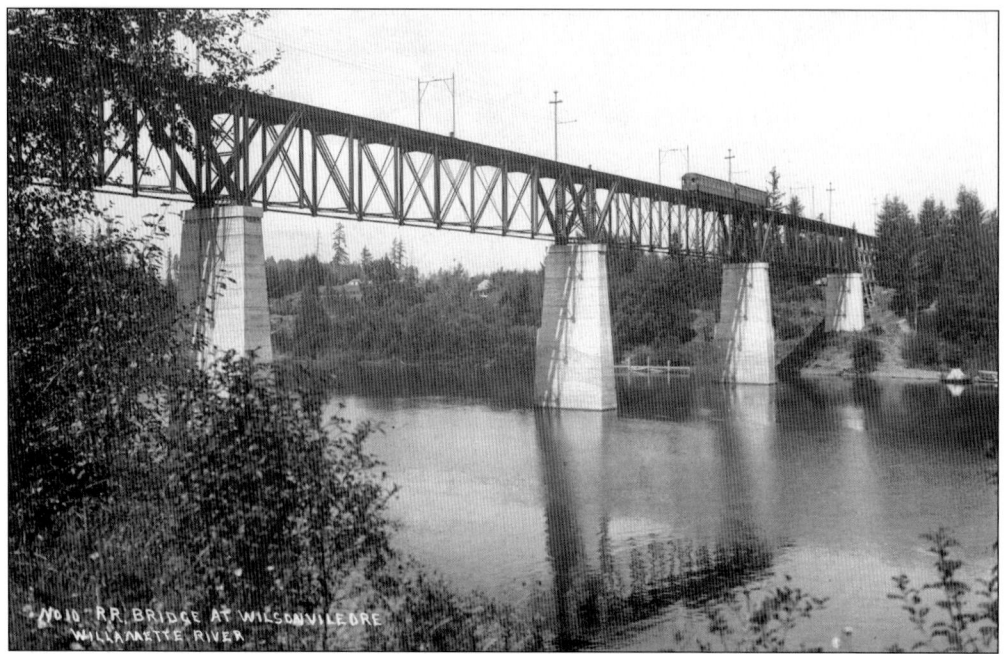

A two-car train has reached mid-span on the 3,422-foot-long bridge over the Willamette River at Wilsonville. The Willamette River Bridge was the most substantial bridge on the Oregon Electric's 70-mile main line. Completed in September 1907, it consisted of four steel spans 46 feet above the high water level. From this point the OE tracks traveled along the east side of the river until reaching Harrisburg. (Courtesy Gholston Collection.)

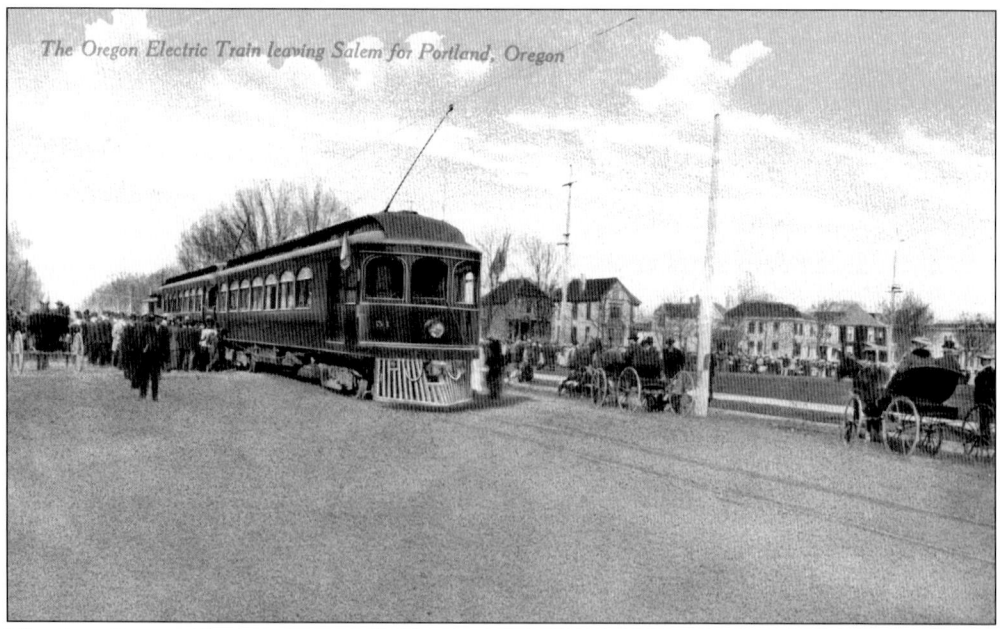

The first Oregon Electric train made the 50.7-mile trip from Portland to Salem on January 1, 1908, an event that is likely depicted on this postcard. Motor No. 51 is seen on the end of a two-car extra departing the state capital. Cars Nos. 50–57 were built by the Jewett Car Company of Newark, Ohio, in 1907 as the railway's first car order. (Courtesy Mark Moore.)

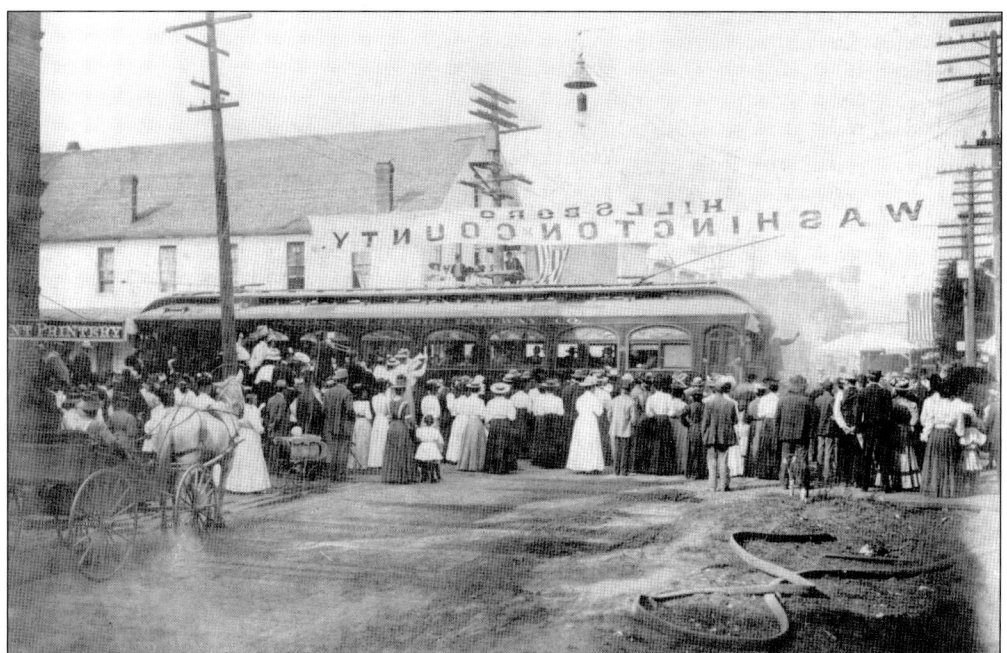

Car No. 51 was dubbed "The Gold Spike Special" for the first official trip to Hillsboro. The remainder of the 19-mile Forest Grove branch was still under construction when this photograph was taken on September 30, 1908. Nine years later, combination baggage and passenger motor No. 51 was destroyed in a fire at Melas Station south of Salem. (Courtesy Washington County Historical Society.)

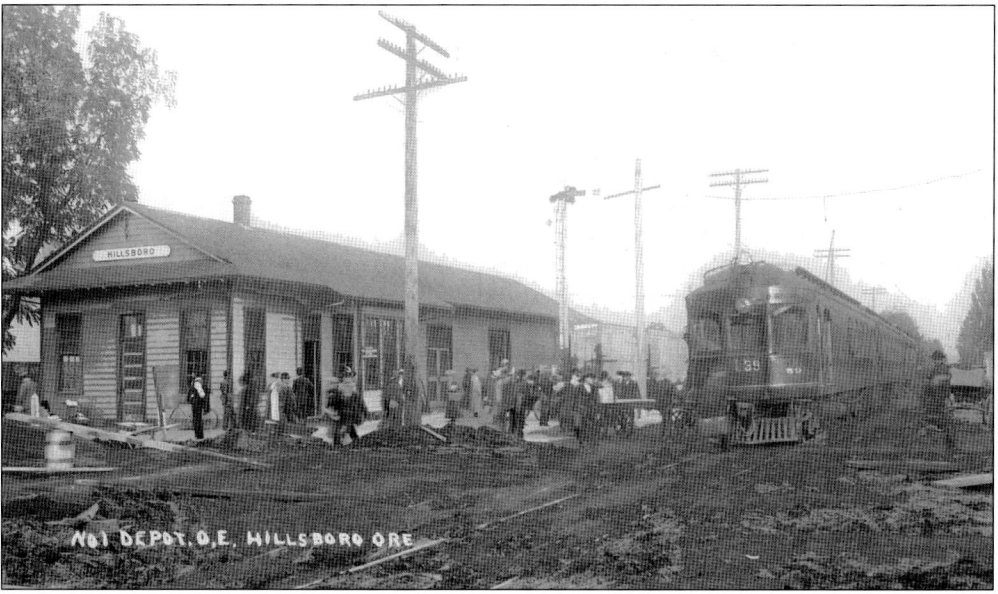

The Hillsboro depot at Third and Washington Streets is still under construction in this busy c. 1910 scene. The baggage wagon has been wheeled up to combine No. 59 as passengers scurry across muddy Washington Street with their bags. The schedule allowed train No. 39 only four minutes before departing for Forest Grove. A MAX light-rail station now stands at this site. (Courtesy Mark Moore.)

Although the Oregon Electric was a long distance railroad, much of its business came from commuters. The company sold six-month booklets of family commutation tickets that were good for one-way trips between Portland and a designated station. This unused ticket for trip 19 is rubber-stamped "Forest Grove" in purple ink. Tickets were usually printed four to a page in books of 25.

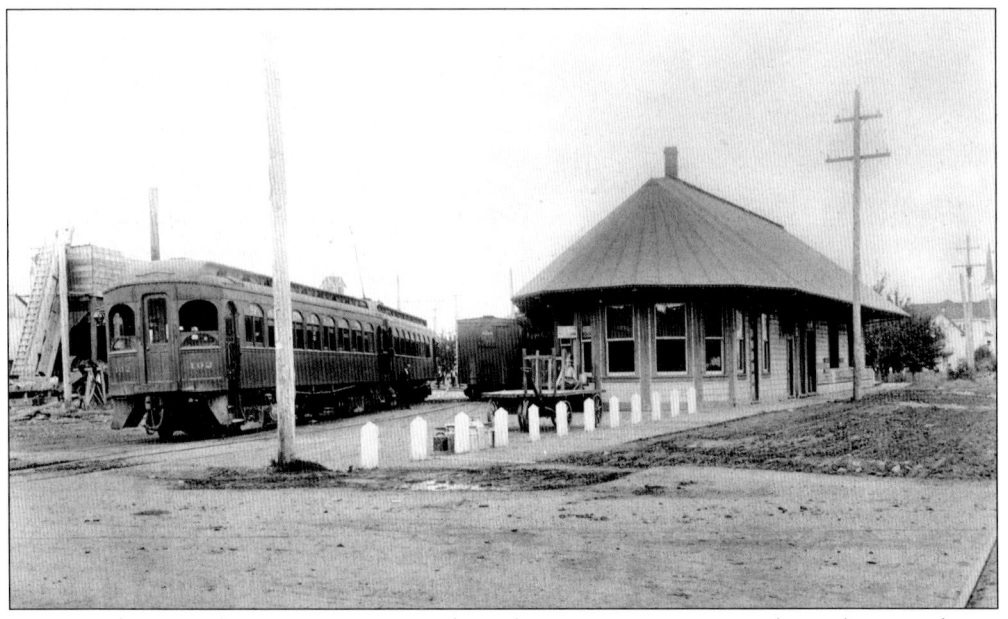

Passengers have not show up yet on a warm, damp day in Forest Grove around 1910, but a conductor stands ready beside Niles trailer No. 102. The Oregon Electric's first branch line, completed on November 15, 1908, was 19 miles in length and 26 miles from Portland's North Bank Station. The wood-frame depot was located at Nineteenth and Ash Streets, not far from Pacific University. (Courtesy Mark Moore.)

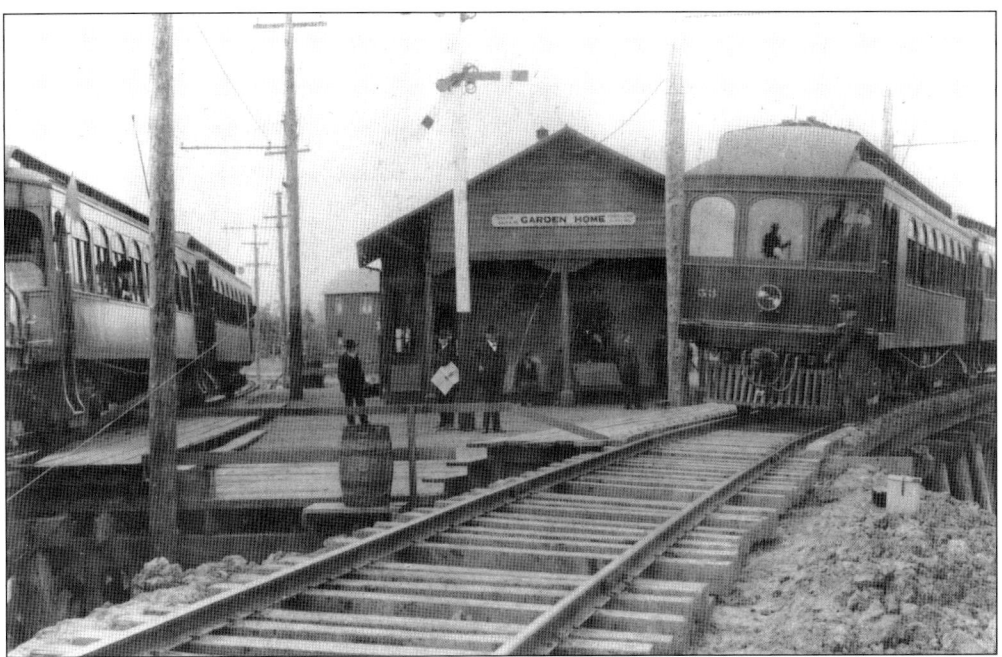

Main line and branch line trains meet at Garden Home, seven miles south of Portland, about 1911. The rustic wood station was between the tracks leading to Tigard and Salem (on the left) and to Beaverton and Forest Grove. The semaphore in front of the station indicates the Forest Grove block is occupied. (Courtesy Kenn Lantz.)

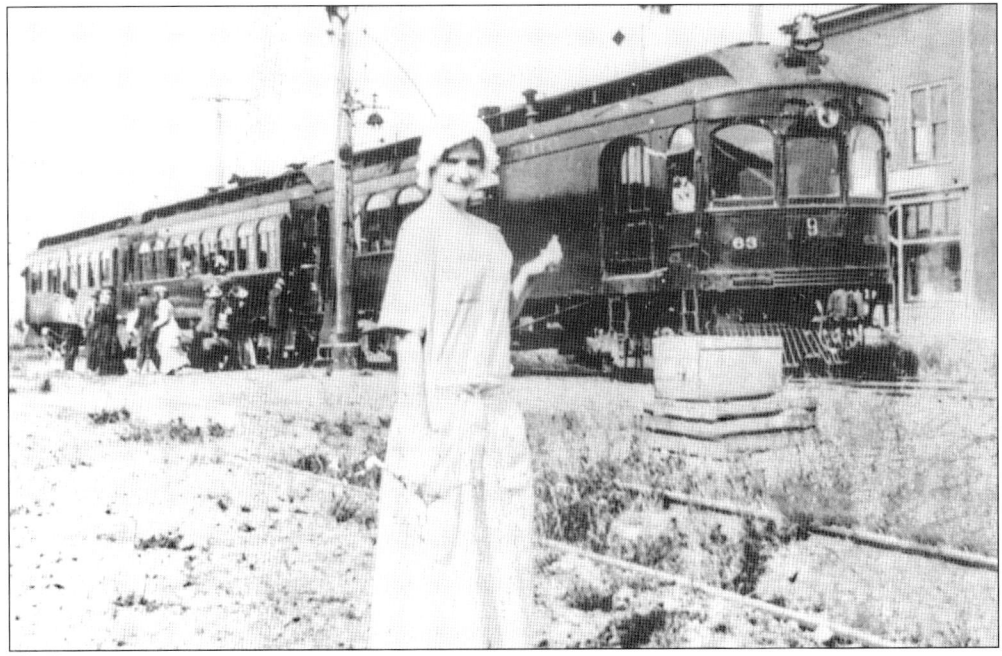

A winsome miss, as they used to say, poses in front of local train No. 9 headed up by combination car No. 63 at Donald Station. Donald was on the main line between Wilsonville and Woodburn, 28.7 miles south of the North Bank depot. The substation here was phased out when the OE converted to 1,200-volt operation.

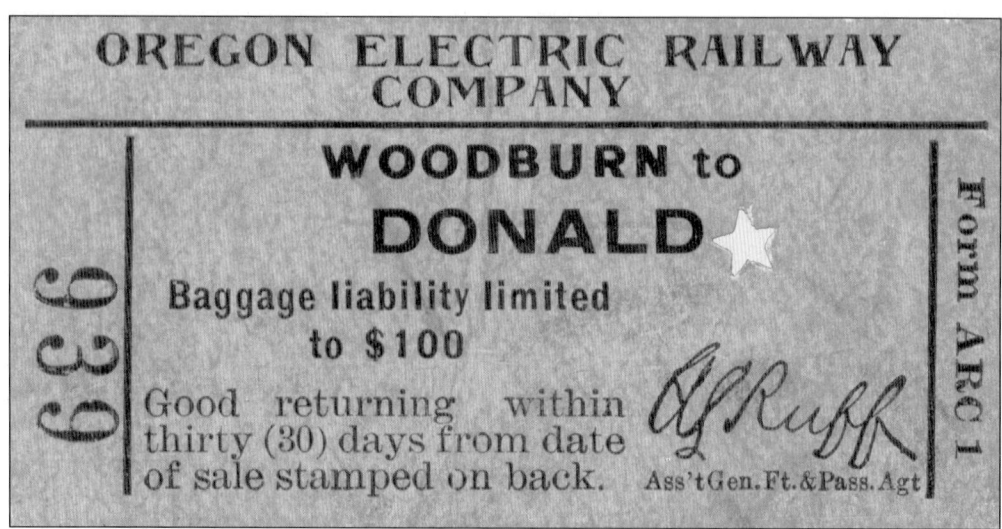

Travel over the Oregon Electric Railway did not need to be for long distances. This ticket, issued September 30, 1912, was valid for 30 days. It was for a trip between Woodburn on the Woodburn branch, and Donald on the Portland main line—a journey passing three stations over a distance of eight miles. The ticket was printed on light red paper.

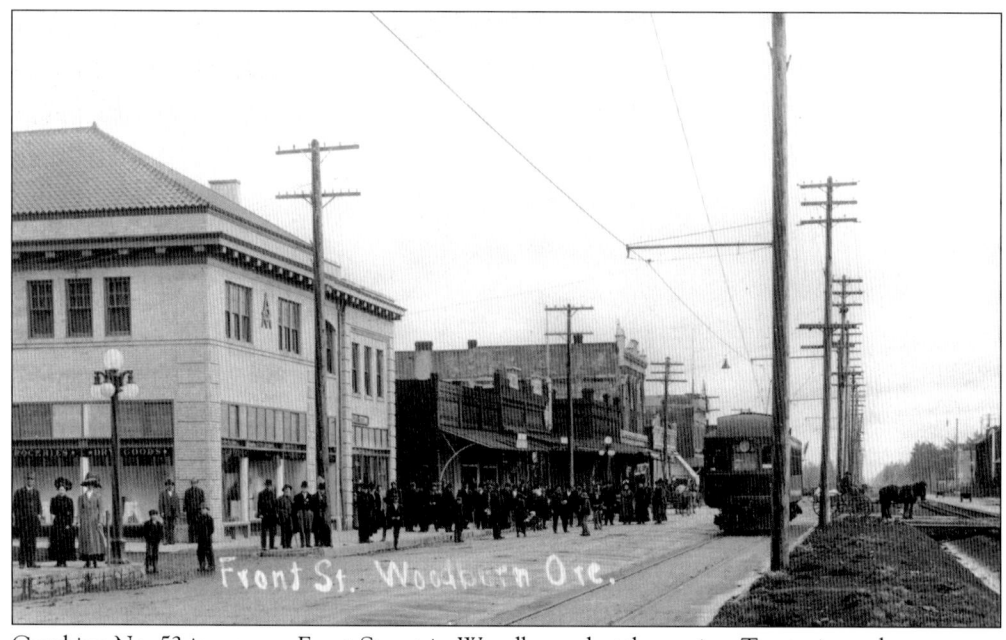

Combine No. 53 is seen on Front Street in Woodburn shuttle service. Ten trains a day ran over the unprofitable Woodburn branch, which was discontinued June 13, 1926. Passengers may have preferred the rival Southern Pacific, whose main line ran directly through Woodburn. (Courtesy Warren W. Wing.)

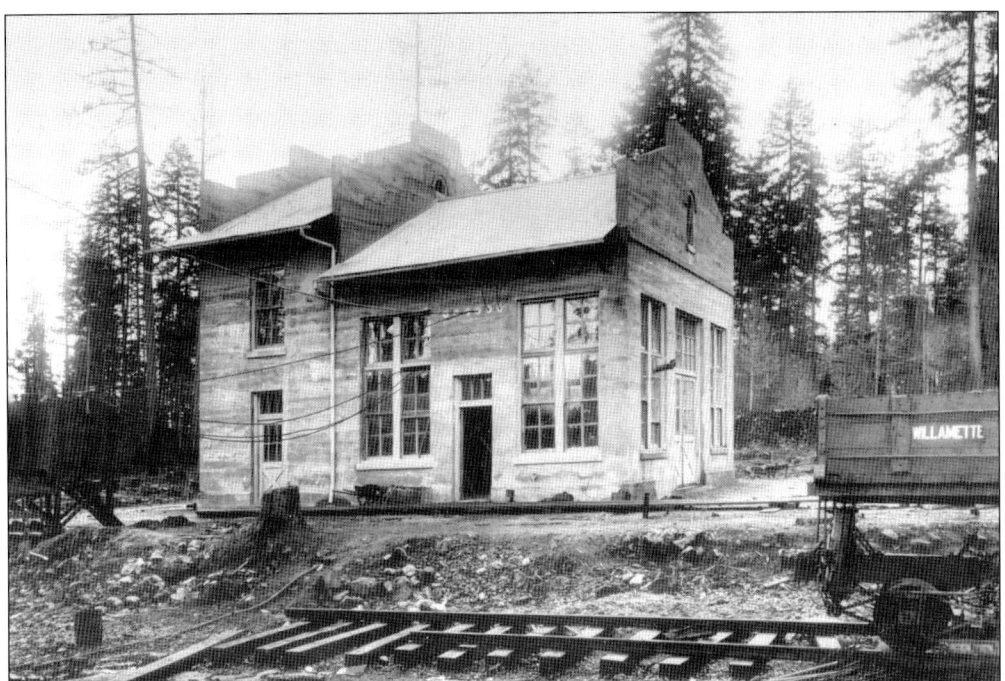

Waconda, seen here during construction, was a combined substation and agent's office. The OE's eight substations, which were located approximately 20 miles apart, included a two-story-high voltage compartment, an electrical operating room, and a ticket office with a waiting room. Station attendants acted in the multiple capacities of station agent, telegraph operator, and electrician.

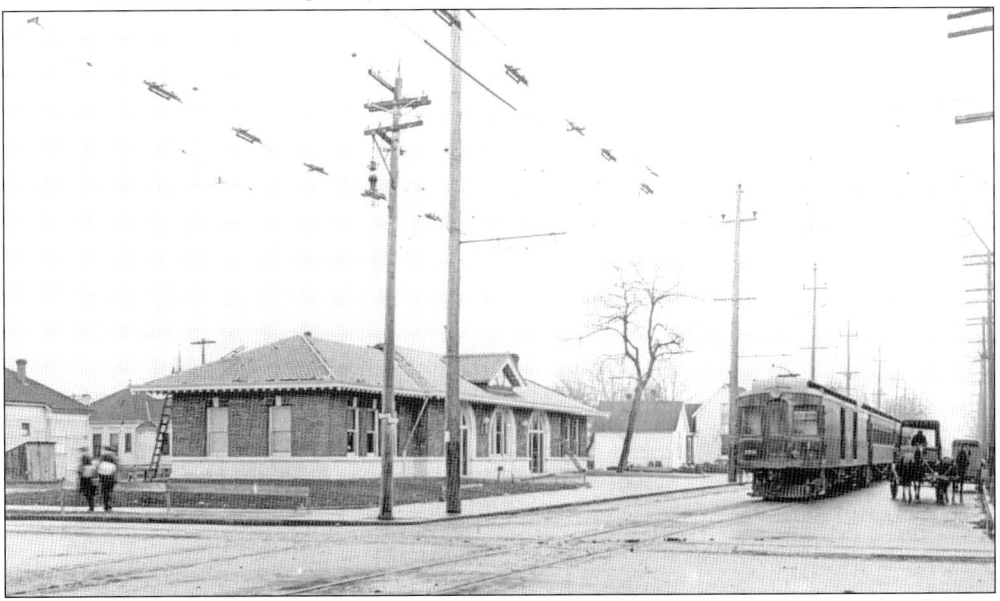

Car No. 150 is seen at Fifth Avenue and Lyon Street in Albany around 1912. July 4, 1912, was a doubly special day as Albany welcomed the first official OE train from Portland. The almost-finished brick depot was of a type heralded as being equal in appointments to those erected by steam railroads in cities of the same size. It survives today as a restaurant. (Courtesy Warren W. Wing.)

35

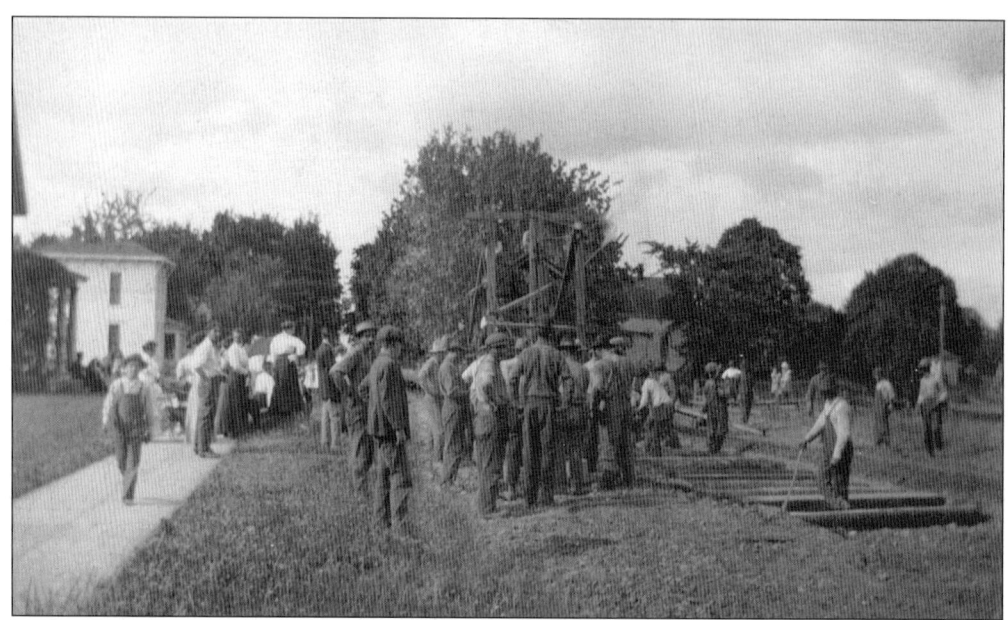

The whole neighborhood watches as a large Oregon Electric crew lays down tracks on Holly Street in Junction City in 1912. This Scandinavian community was 108.2 miles south of Portland on the OE main line. Passengers could transfer to stages here for Blackly and Deadwood. (Courtesy Mark Moore.)

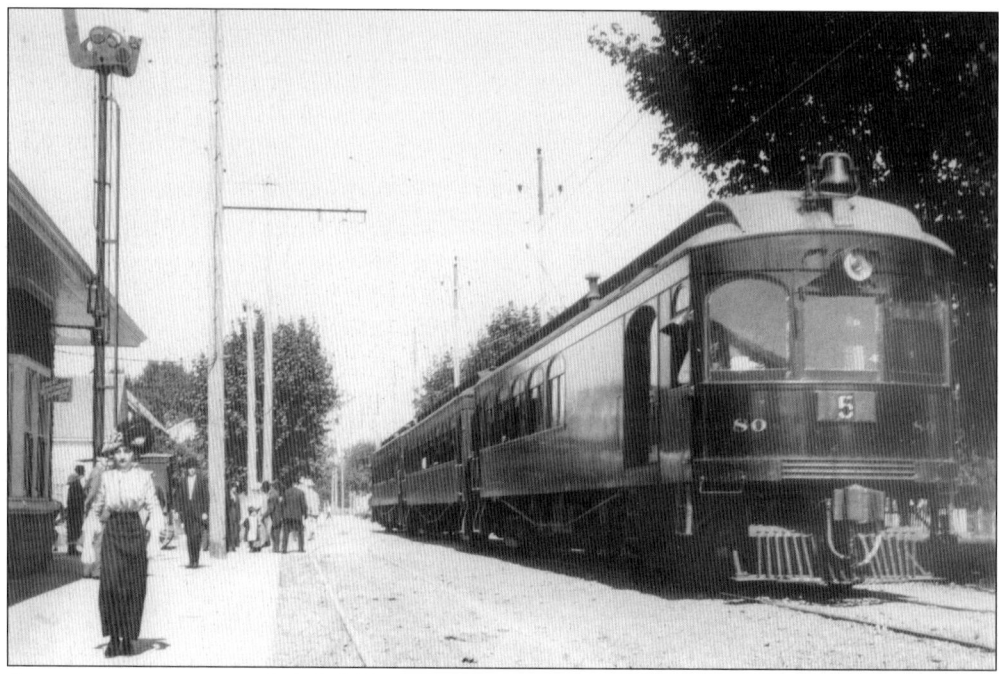

A young woman in a stylish hobble skirt walks away as the Portland-Eugene express departs Junction City around 1914. The semaphore has given the all clear for Eugene, eight stops to the south. The sign on the side of the station is for the Great Northern Express Company. Combine No. 80 was destroyed in the OE shops fire on January 3, 1932. (Courtesy Oregon Historical Society, OrHi 39328.)

A Eugene local waits for the photographer to get off the track at Meadow View Station, 112.9 miles south of Portland. The distinctive chalet-style shelter station had no ticket agent but offered 8-foot-wide waiting and freight rooms. Combination baggage and passenger car No. 61 was built by the American Car Company of St. Louis, Missouri, in 1912. (Courtesy Warren W. Wing.)

Four years passed before Oregon's longest interurban reached its Eugene terminus. On October 15, 1912, about 25,000 people celebrated what the *Morning Register* called the "greatest day in the history of Eugene." The standard freight depot, seen here, served as Eugene's passenger station for 19 months. Five trains departed for Portland daily, including limiteds, locals, and "owl" trains equipped with sleeping cars. (Courtesy Mark Moore.)

37

The elegant Albany Limited, seen here rolling through a forested part of the Willamette Valley, exemplifies an Oregon Electric train of this type. The three-car train includes combination baggage, smoking, and passenger motor No. 54, followed by passenger trailer No. 115, and parlor observation car No. 1000 Sacajawea. All cars featured inlaid mahogany interiors with silk curtains

and a colored-glass upper sash. The parlor car included a smoking compartment with a sofa, buffet, and lavatories. Seating in the main part of the car was on cushioned wicker chairs. The rear observation platform was 8 feet long and enclosed with a brass railing. No. 54 was built by Jewett in 1907, No. 115 by the American Car in 1912, and No. 1000 by Niles in 1910.

A train rests at Eugene after completing a three-and-a-half hour journey from Portland. Not bad time for a 122.2-mile run in the 1910s. The $30,000 brick depot at Fifth and Willamette Streets opened for business May 4, 1914. The passenger station is used today as a restaurant. The nearby freight depot, which had served as Eugene's first OE passenger terminal, lasted into the late 1950s. (Courtesy Gholston Collection.)

Observation parlor car No. 1001 Champoeg is awaiting passengers next to the Salem ticket office in 1924. In Albany and Eugene, the Oregon Electric depots were devoted entirely to railroad purposes, but in Salem, the station shared the ground floor of the Hubbard Building with the Oregon Theatre and other businesses. The building at State and High Streets still stands.

40

At its peak, the Oregon Electric offered eight daily trains to Salem. The Supreme Court Limited departed Portland at 8:00 a.m. and reached Salem two hours later. Attorneys were allowed 10 minutes to get from the station to the court. The buildings illustrated in this advertisement include the old capital and the Pittock Block at Southwest Tenth Avenue and Washington Street in Portland, which housed the OE offices.

Between Washington Street
AND
The Capital
Oregon Electric R'y Service Sets the Pace

WASHINGTON STREET

INTERESTING LEGISLATIVE SESSIONS DAILY AT

SALEM

FARES: Between Portland and Salem

ONE WAY$1.50
ROUND TRIP, DAILY........$2.75
(GOOD FOR 30 DAYS)
ROUND TRIP, WEEK END....$2.00
COMMUTATION, 30-RIDE...$30.00

Low Week-End Fares to Salem from other points
Trains to Salem at 6:30, 8:30 (limited), 10:45 a. m., 2:05, 4:40 (limited), 6:05, 9:20, 11:45 p. m. Additional stops at 10th and Stark, 10th and Morrison, 5th and Salmon, 2d and Salmon.

TICKET OFFICES
5th and Stark, 10th and Stark, Seward Hotel, 10th and Morrison Sts., North Bank and Jefferson-street Stations.

People adorned in their Sunday best relax on the observation platform of parlor car No. 1000 Sacajawea as their three-car limited train glides through a residential section of Salem, probably on High Street. The beautiful Sacajawea was destroyed by fire at Fellers Station, 30 miles south of Portland, on July 28, 1924. (Courtesy Mark Moore.)

41

An unidentified motorman (wearing a bow tie) and conductors George Bullard and "Uncle" Dave (far right) pose with train No. 7, the Corvallis Local, which was due to depart North Bank Station at 10:00 a.m. for the four-hour trip south. A dispute with Union Station owners Southern Pacific, Union Pacific, and Northern Pacific forced the OE to make North Bank Station their Portland terminus. (Courtesy Mark Moore.)

An Oregon Electric "Hop Picker's Special" is loading at the Jefferson Street Station on Southwest Front and Jefferson Streets in 1914. The growers provided pickers with shelter, but they had to bring just about everything else for their seasonal stay in the hop yards of the Willamette Valley. (Courtesy Oregon Historical Society, OrHi 106006.)

The Oregon Electric was not partial to either the Ducks or the Beavers, as can be seen in this 1920 promotion. Unlike the rival SP Red Electrics, the OE served both the University of Oregon in Eugene, and Oregon Agricultural College (now Oregon State University) in Corvallis. Students' specials ran straight through to both towns, saving up to 30 minutes over regular trains.

STUDENTS'
Special Trains
VIA
Oregon Electric Railway
TO
Corvallis and Eugene
SUNDAY, NOVEMBER, 28

	For Corvallis.	For Eugene.
Leave North Bank Station	4:38 P. M.	4:39 P. M.
Leave Jefferson-St. station	4:55 P. M.	5:10 P. M.
Arrive Corvallis	7:40 P. M.	
Arrive Eugene		8:45 P. M.

These are separate trains running directly to Corvallis and Eugene, and accepting passengers for these points only.

Students will note that the leaving time is slightly earlier than heretofore stated.

Stops to receive passengers will be made at Tenth and Stark sts., Seward Hotel, Salmon and Fifth sts., Salmon and Second sts., in addition to North Bank and Jefferson-street stations.

Tickets may be obtained at North Bank Station, Tenth and Stark sts., Seward Hotel, Tenth and Morrison sts. and Jefferson-street station.

Oregon Electric Railway

Two ladies wait in the back seat of an open touring car while baggage is retrieved from combination car No. 63 at the Corvallis Oregon Electric station c. 1914. The three-car train includes two new 120-series passenger motors built by the American Car Company in 1913. Passengers on this train, which would have run straight through from Portland, were likely students at Oregon Agricultural College. (Courtesy Oregon Historical Society, OrHi 28370.)

This picture of No. 52 presents interesting interior details of an Oregon Electric combination car. The view looks from the rattan walkover seating in the smoking compartment, to the dark green upholstered seats in the main passenger section. Etched-glass panels separate the two compartments. The baggage compartment is out of view behind the photographer. (Courtesy Oregon Historical Society, OrHi 51277.)

The sleeping compartment in No. 1010 Santiam and No. 1011 Calapooia offered 10 fold-down sleeping sections similar to those found in main-line steam trains. Walls were of inlaid mahogany, seats were upholstered, and hardware was bronze. Ceilings were painted in green with gold trim. The lavatories and smoking room were located at the ends of the car. (Courtesy Oregon Historical Society, OrHi 51273.)

The Oregon Electric Railway's elegant parlor-observation car No. 1001 Champoeg provided all the comforts of home, including the latest in entertainment technology. This publicity photograph of gentlemen listening to a Model 55 Atwater Kent radio was taken on the "Luckenbach Special" to Eugene in November 1929. Before long, the Great Depression would wipe out such luxuries, as well as the railroad itself. (Courtesy Mark Moore.)

In 1913, the OE ordered two sleeping cars from the Barney and Smith Car Company of Dayton, Ohio. Both Santiam and Calapooia are seen here at Eugene during that first year. They ran on an extended 10-hour schedule (regular trains required only 4 to 5 hours) so that they would not arrive at their destinations until the next morning. These unique sleepers were withdrawn from service in 1919.

Cloche-hatted passengers clamber from Ryan Place Station onto a three-car OE train c. 1926. What a thrill it must have been to move from the cramped little chalet into the warmth and elegance of a car like the 57-foot-4-inch-long No. 138, seen here, with its inlaid woods, silk curtains, and adjustable upholstered seats. (Courtesy Oregon Historical Society, OrHi DB23-B.)

On January 3, 1932, the OE's Porter Street Shops in Portland were destroyed by fire. Defective wiring is thought to have started the late-night blaze, which destroyed the 200-by-125-foot building. The shops housed a machine shop, paint shop, blacksmith shop, and storeroom. Damage to combines Nos. 64, 80 and 120 (pictured), locomotive No. 22, and line car No. M-35 totaled $57,000.

Twilight fell across the magnificent Oregon Electric system in the 1930s. Yet, even in their waning years, OE trains were so reliable that one could set his clocks by their passing, as depicted in this original advertising art from 1930. Perhaps the imaginary train is the Eugene Express, which passed through Donald at 7:17 p.m. as it whistled its way down the valley at an average speed of 30.5 miles per hour. Fare for the 122-mile trip was $6. A new logo replaced the familiar OE diamond during the railroad's last three years of passenger service.

This map of interurban railways in the Portland area shows the United Railways (UR) line between Portland and Banks. From the western terminus at Banks, a steam railway continued northward to Vernonia to serve a large lumber mill. Another connection was with the Gales Creek and Wilson River Railroad (GC&WR), a logging operation that fed logs to the UR at Wilkesboro. Between 1957 and 1995, the Oregon Electric Railway Historical Society's Trolley Park museum was located at the site of the GC&WR shops at Glenwood. Notice also the Orenco cutoff, which allowed equipment to be exchanged with its sister Oregon Electric Railway. This map was originally published in the *Pacific Railway Journal*. (Courtesy Donald Duke, Pacific Railway Journal Archive, Golden West Books.)

Three
UNITED RAILWAYS
(1911–1923)

As Portland became a hub of electric railway building, interest turned toward the Tualatin Valley to the west. Between 1895 and 1905, various plans were put forth to build an electric railway westward to the Oregon Coast via Forest Grove. But a lack of funds and legal wrangling delayed construction until the incorporation of United Railways in 1906.

In 1909, railroad magnate James J. Hill acquired United Railways (UR), which began sharing trackage and facilities in Portland with its sister railway, Oregon Electric. On March 21, 1911, a 4,107-foot tunnel was completed under Cornelius Pass, and construction of the UR line westward toward Banks accelerated. On April 16, 1911, regular electric service began to Wilkesboro.

The railroad founded the new towns of Burlington and North Plains along its route. The 28-mile journey took 1 hour and 35 minutes. In the early 1920s, a 1.2-mile extension was made to Banks, which became the western terminus. Original plans had called for tracks through to Tillamook, but United Railways never built beyond Banks.

The United Railways owned seven regular passenger cars, three combination cars, and one freight motor. All but one of these classic wooden interurbans were built by the American Car Company of St. Louis, Missouri. UR also borrowed equipment from the Oregon Electric. When the Oregon Electric converted from 600- to 1,200-volt operation in 1912, UR did likewise.

The UR might have become a commuter railroad serving suburbs to the west of Portland, but the region was sparsely settled and business was damaged by a bitter fare dispute in 1915 that resulted in passenger service being cut between Portland and Linnton. Riders for Portland were forced to transfer to Spokane Portland and Seattle Railway (SP&S) main-line steam trains at Linnton. As ridership plummeted, some passenger trains were dropped from the schedule and others were converted to slow mixed freights. On January 18, 1923, electric passenger service was eliminated in favor of steam, and United Railways passenger cars were transferred to the Oregon Electric. In 1943, United Railways was absorbed into the SP&S.

The United Railways Company issued $3 million of capital stock in shares of $100 each. Within months the railway was short of funds and seeking a bank loan. The 12 and 1 half shares seen here were among the first $5,000 authorized. They were issued to company treasurer and secretary Wilmot Griffiss. (Courtesy Mark Moore.)

This 1909 builder's photograph of United Railways combination baggage, express, and passenger car No. 5 shows classic wooden interurban design. UR rolling stock was painted Pullman green and featured oak and mahogany interiors. It was converted to Oregon Electric work car No. X424 in 1932 and was scrapped in 1935. (Courtesy Donald Duke, Pacific Railway Journal Archive, Golden West Books.)

In this photograph, passenger motor No. 3 had reached the end of electrified track at Wilkesboro during the early years of United Railways operation. Wilkesboro was the western terminus of UR electric passenger service for many years. The single passenger sitting next to the attractive station may be evidence that the Tualatin Valley was too lightly populated to support an interurban railway. (Courtesy Donald Duke, Pacific Railway Journal Archive, Golden West Books.)

This crude 1913 builder's photograph of No. 10 is from a J. G. Brill catalog. Cars Nos. 10–13 were the last four cars purchased by United Railways. Like all but one car, they were built by the American Car Company of St. Louis (a Brill subsidiary). This series moved over to the Oregon Electric in 1923. (Courtesy Donald Duke, Pacific Railway Journal Archive, Golden West Books.)

This detailed sketch by artist Bob Carlson showing freight and passenger trains passing near North Plains was based on the photograph on the next page. The family relationship with the Oregon Electric Railway is clear as one can see a two-car train consisting of United Railways No. 10 and Oregon Electric baggage motor No. 901 come off the trestle. The freight at right has gone "in the hole" to wait for the passenger train. It is led by 50-ton Oregon Electric steeple cab

No. 2, which was assigned to the UR line for many years. Wooden boxcar No. 9136 reflects freight interchanged with the SP&S, another of Jim Hill's railroads. (Courtesy Donald Duke, Pacific Railway Journal Archive, Golden West Books.)

United Railways baggage-passenger motor No. 13 is seen approaching the long trestle near North Plains c. 1913. Three farms are visible in the distance, but much of the route crossed unpopulated country and forest. Car No. 13 was the highest numbered car on the UR roster and went into service in March 1913. It had a capacity of 60 passengers. (Courtesy Donald Duke, Pacific Railway Journal Archive, Golden West Books.)

This c. 1911 view shows the motorman leaning against extra No. 3 at Wilkesboro Station. Passenger counts fell in 1915 when through service to Portland was cut in a fare dispute with the town of Linnton. Expenses were already being cut in 1913 when the motors were removed from No. 3 and it became a passenger trailer. Note the passengers scurrying past boxes at the far left.

54

This undated photograph is thought to have been taken at North Plans on the UR line to Wilkesboro. It must be a warm afternoon, as people are talking in the shade of a United Railways boxcar or walking into a store advertising ice cream. By 1918, only one mixed passenger and freight train was operating daily between Linnton and Wilkesboro.

The handwriting was on the wall when this car mileage payment was made to parent SP&S in 1921. United Railways seldom made enough money to repay its debts. Plans to expand toward the coast had been dropped after the Pacific Railway and Navigation Company reached Tillamook in 1912. In addition, there was little chance of drawing traffic from towns to the south after the SP completed Red Electrics service in 1914.

United Railway's only freight motor was used primarily in Portland. No. 1 is seen here next to the Weinhard Brewery on Northwest Twelfth Street c. 1909. The 35-ton locomotive was acquired from Baldwin in January 1908. It was renumbered as Oregon Electric No. 15 in 1911 and sold to Yakima Valley Transportation in 1914, where it continued as YVT 299 until its scrapping in 1958. (Courtesy Oregon Historical Society, OrHi 52082.)

Oregon Electric freight motor No. 2 was used to haul freight across the Tualatin Valley for United Railways. The 50-ton steeple cab was built by the American Locomotive Company in 1910. It was sold after dieselization in 1945. This picture was taken near the end at OE's Porter Street Yards in Portland. Baggage motor No. 41, lurking in the shadows, was also used on United Railways.

This photograph of former United Railways combine No. 10 at the Oregon Electric freight depot in Portland was taken by street repair crews on November 17, 1934. UR passenger service had been abandoned 10 years before. Car No. 10 retains a look of elegance amidst a rough setting. Note the crude line-repair cars to the right. (Courtesy Donald Duke, Pacific Railway Journal Archive, Golden West Books.)

Oregon Electric No. 136 was originally one of the United Railways Nos. 10–13 series of baggage-express cars. It had been acquired as a trailer, with motors added July 23, 1913. The car was renumbered and used regularly on the OE after 1923. In this view, taken prior to its sale to Weyerhaeuser in 1936, the car's interurban lines peek through peeling paint. (Courtesy Warren W. Wing.)

This map from a 1926 timetable shows the Southern Pacific Red Electrics lines three years prior to abandonment. The Yamhill Loop is clearly illustrated, as well as the extension to Corvallis, which became the southern terminus. A planned extension to Eugene was delayed by World War I, after which a decision was taken not to build. Connections to short-line steam railroads are also shown. The distance from Portland to Corvallis was 88 miles. Overall electrified mileage totaled 180.

Four

SP RED ELECTRICS
(1914–1929)

The Southern Pacific (SP), which controlled most of the railroads in Oregon, became part of the Edward H. Harriman empire in 1901. Soon after rival railroad mogul James J. Hill purchased the Oregon Electric, Harriman took steps to compete. With successful electric railway experience in California under his belt, he made the decision to convert branch railroad lines in Oregon into an electric interurban network.

Initial efforts were made under the banner of the newly acquired Portland, Eugene, and Eastern Railway (PE&E). The PE&E operated city streetcar systems in Salem, Albany, Eugene, and West Linn and planned an electric line linking them to Portland. In 1912, the SP added their Westside and Yamhill branches to the PE&E system and began electrification. The PE&E name was replaced with Southern Pacific Lines in 1915.

Electric interurban service began January 17, 1914, over two routes running from Portland to Whiteson, south of McMinnville. The West Side Line went via Beaverton, Hillsboro, and Forest Grove, while the East Side Line ran through Oswego, Tualatin, and Newberg. These lines joined at St. Joseph, creating a 109-mile-long circle route that became known as the Yamhill Loop.

On June 17, 1917, the 88-mile line to Corvallis, which would become the SP's southern terminus, was completed. A planned extension to Eugene was never realized. By 1920, sixty-four trains a day were operating over 180 miles of electrified track. Four daily trains ran to Corvallis and two to Whiteson. Frequent one- or two-car commuter trains operated close to Portland.

SP's all-steel Red Electrics ran on 1,500 volts and sported pantographs like their cousins in Northern California. The huge, porthole-like windows at each end were a distinctive Oregon feature. These modern Pullman-built cars may not have been as elegant as Oregon Electric's parlor cars, but they offered faster service.

The Red Electric system was one of the last interurban railways built and one of the first to be abandoned, lasting just 15 years. After a decade of decline, electric passenger service was abandoned on October 5, 1929.

This 1880s panorama of South Portland shows the trestle over Marquam Gulch, a route that would later be followed by the Southern Pacific. The Red Electrics ran through Portland along Southwest Fourth Street, leaving town via a right-of-way that is Barbur Boulevard today. The tracks of rival Oregon Electric ran a few blocks away on Macadam Avenue. The two railways diverged near Burlingame, where the Red Electrics turned west.

Before the arrival of the Red Electrics, gasoline-powered "doodlebugs" like No. 41 helped cut operating expenses on marginal branch lines. The car is seen in Brownsville about 1910. After electric operation commenced, their use increased on lines like the Falls City branch, which fed the Westside line. The SP began ordering the streamlined combines from the McKeen Motor Car Company in 1908. They were not used after 1930.

Car No. 202 and a sister car still bear the Portland Eugene and Eastern (PE&E) name as they load passengers not long after the beginning of Red Electrics passenger service on January 17, 1914. Cars Nos. 200, 201, and 203 were the first three passenger motors placed in service. In August 1915, the fleet was re-lettered to reflect parent company Southern Pacific. (Courtesy Gholston Collection.)

The Steel Bridge looms behind PE&E No. 208 at Portland's Union Station c. 1914. Due to their height, the Red Electrics used pantographs to collect power instead of trolley poles. No. 208 was a standard 60-passenger car built by Pullman in 1912. It was placed into service on March 25, 1914. (Courtesy Mark Moore.)

61

Conductor Kline checks his watch as the PE&E commuter train No. 105 readies for its 4:10 p.m. departure for Oswego and way points on April 26, 1914, during the initial year of electric service. The Red Electrics could take advantage of convenient connections at Portland Union Station. During this period, 36 trains arrived or departed daily. (Photograph taken by Sartwell; courtesy Mark Moore.)

Oswego local No. 323 waits on track No. 1 at Union Station in 1914. Pantograph, roof-mounted bell, MU connector, marker lights, headlamp plugs, and the prominent grab handles to each side of the train door can clearly be seen in this close-up. The Southern Pacific's first car order from the Pullman Company of Chicago included 13 passenger cars, 17 combination baggage and passenger cars, 5 baggage express cars, and 11 passenger trailers.

Southern Pacific's motor cars were equipped with General Electric US type 122 rolling pantographs with double sliders. Pantographs on all the cars in a train could be raised and lowered electro-pneumatically by the motorman in the front car; however, this practice was discontinued in favor of manual operation because it sometimes broke the overhead wire. This close-up view of pantograph maintenance was taken at Portland's Union Station c. 1914.

Brakemen Dave Stevens (far left) and "Jake" pose with an unidentified conductor and engineer next to the No. 2 end of a baggage express motor. Southern Pacific ordered five baggage express cars from Pullman in 1913 and another three from J. G. Brill the following year. The riveted steel construction and heavy duty Baldwin trucks are clearly seen in this undated close-up. (Courtesy Mark Moore.)

The PE&E car shop was located on the eastern outskirts of Beaverton, as seen in this rainy illustration from the February 14, 1914, issue of the *Electric Railway Journal*. The first trial run of a Red Electric train was made from the Beaverton shops to Gaston on January 5, 1914. Two of the railway's three steeple cab freight motors, headed by No. 101, are parked at the left.

The Beaverton Shop was intended as a temporary repair facility but remained in use throughout Red Electrics operation. Original plans called for construction of permanent shops at West Linn. The shop facilities included electrical repair rooms, painting areas, and general repair areas featuring large drills and lathes, as seen in this 1915 *Electric Railway Journal* illustration.

A crewman peers at the camera from the open freight door of baggage express car No. 604 on a foggy morning in 1915. Train No. 351 made the 17-minute trip from Whiteson to St. Joseph each morning, sometimes with a five-car consist, as seen here. Note the Wells Fargo and Company Express sign.

Passengers queue up to board McMinnville Local train No. 108 at the new Forest Grove depot on the corner of Main and Nineteenth Streets c. 1915. From Portland, the Red Electric West Side line traversed the Tualatin and Yamhill Valleys, serving the communities of Beaverton, Hillsboro, and Forest Grove, before turning south toward McMinnville. Forest Grove was 27 miles from Portland's Union Station.

A three-car inbound Reedville Local is held captive by Jack Frost in this winter scene on Fourth Street in downtown Portland, probably during the big snow of 1916. Contact with the overhead wire has been improved through the installation of high platforms beneath the pantographs, although it was not always effective in a storm like this. The sign in the foreground reads, "Congested district safety first."

The Red Electric was one of the first railways in the country to operate on a line tension of 1,500 volts. Concrete substations were erected at Oswego, Forest Grove, Dundee, McCoy, and Wellsdale. Like the Oregon Electric, SP's rolling stock was required to operate on 600 volts while in Portland. This view of the Wellsdale substation was taken soon after its completion in 1916. (Courtesy Oregon Historical Society, OrHi 43846)

Combination passenger and baggage car No. 511 heads up an East Side local at Corvallis in this undated photograph. Construction on the 43-mile extension from Whiteson to Corvallis got under way in 1916. Passenger service between Portland and Corvallis was inaugurated on June 17, 1917, with somewhat less excitement than had greeted the first Red Electrics three years before. (Courtesy Warren W. Wing.)

The conductors flank the engineer in front of combine No. 510 at the Corvallis depot. Corvallis High School is in the background. Corvallis was the southern terminus for East Side local trains, such as No. 358, seen here during the 1920s. West Side locals terminated at Whiteson, just south of McMinnville. (Courtesy Warren W. Wing.)

Portland-bound East Side local train No. 358 awaits passengers on Main Street in Newberg in 1918. The waiting passengers are standing in front of a small nickelodeon-type movie theater next to the ticket office. (Courtesy Mark Moore.)

Red Electric train No. 358, which originated in Corvallis, pauses in front of the Imperial Hotel on Main Street in Newberg about 1920. (Courtesy Mark Moore.)

Hostler Gene Moell (leaning out the window) and his assistant are about to move Red Electric passenger motor No. 207 at Union Station in 1918. Hostlers switched cars to make up trains, checked brakes and wiring, and performed minor adjustments to equipment. Before the workforce reductions of the 1920s, electrically qualified hostlers were assigned to Union Station, Forest Grove, Hillsboro, and Corvallis, as well as to the shops.

Three conductors and a motorman stand alongside Oswego local No. 311 at Oswego Station c. 1920. The community of Oswego (named for Oswego, New York) was founded in 1853. The name was changed to Lake Oswego when Oswego and Lake Grove merged in 1959. Note the brass air whistle next to the marker light on the left corner of the roof.

The worst accident in Oregon interurban history occurred at 10:23 a.m. on Sunday, May 9, 1920, on a blind curve just east of Bertha Station. Train No. 124, inbound from Hillsboro and heading to Portland, collided head-on with train No. 107, which had departed for McMinnville 20 minutes earlier. Five passengers and three employees died instantly, and 102 others were injured, most on the first car of train No. 107. (Courtesy Mark Moore.)

Investigators blamed the Bertha wreck on engineer Cy Willetts and conductor Austin Pharis, who had ignored a train order establishing a meeting point at Bertha. Willet's gloved hand dangles from underneath a white cloth covering his body in this grim scene. It was difficult to extricate bodies from the twisted wreckage. As a result of this accident, block signals replaced the staff system on additional sections of the SP line.

On a rainy Portland day in 1920, McMinnville motor coach No. 502 leads train No. 107 up to the original Red Electric Fourth Street ticket office. The Fourth Street Station, located at 131 Fourth Street, opened January 27, 1917. (Courtesy Mark Moore.)

The Southern Pacific opened a new ticket office on the corner of Southwest Fourth and Stark Streets on March 31, 1921. The Stark Street Station included a ticket counter, comfortable seating, and plenty of windows for reading. Note the Southern Pacific Lines logo on the windows. (Courtesy Oregon Historical Society, OrHi 88776.)

Southbound Red Electric mail coach No. 516 enters the north portal with one of the first trains through the newly opened Elk Rock Tunnel in December 1921. Combination motor coach and mail car No. 516 was converted from passenger and baggage car No. 501 and featured a mail-sorting "apartment" at one end of the 42-passenger coach.

Mail coach No. 515 has paused with Cook local train No. 304 for a publicity photograph commemorating the opening of the Elk Rock Tunnel on December 5, 1921. Prior to this time, Southern Pacific trains had to take a long trestle around Elk Rock. Cook was the location of a cutoff used mainly for hauling equipment between the East Side and West Side lines.

In 1922, SP rebuilt four baggage and passenger cars (Nos. 500, 502, 515, and 516) into combination railway post office–and–passenger cars. No. 501, shown here newly out-shopped at Beaverton, was the only one of the group not to have its exterior changed and the only one to avoid the scrap yard after it went to the PE in 1928. The higher pantograph was added about 1916. (Courtesy Warren W. Wing.)

The baggage carts are empty, and no passengers bustle on the boarding platform, but the pans are up and combine No. 513 is ready to lead a three-car train out onto the main line in this quiet scene taken at Union Station in 1923. The 10-year-old Broadway Bridge looms large overhead. A Northern Pacific Railroad coach sits at the right. (Courtesy Warren W. Wing.)

A standard Red Electric three-car train, consisting of combination baggage-passenger coach No. 507, passenger trailer No. 485, and passenger coach No. 213, rumbles across the trestle between Rex and Springbrook in 1925. Orchards spread as far as the eye can see across the Chehalem Valley. The first two cars were placed in service in 1914, while No. 213 was among the second, and last, group of cars ordered from Pullman. Six passenger motors and six passenger trailers

74

went into service in June 1921. They were virtually identical to the original Pullmans. Standard specifications for Southern Pacific's Oregon passenger cars were 56 feet and 10 inches long, 9 feet and 8 inches wide, and 13 feet and 4 ¾ inches high. These riveted steel cars were the latest in interurban technology, with 110-horsepower GE type 205 motors, Westinghouse air brakes, and Baldwin MCB trucks. Interiors sported mahogany trim and green plush seating.

Southern Pacific Red Electrics FROM PORTLAND to Beaverton, Hillsboro and Forest Grove											
Stations	Miles	✦121	*127	*129	*123‡	†131	†133	*125	*137	*135	*139
Lv. PORTLAND Union Station....	.0	7.55	10.45	1.25	3.45	4.45	5.15	6.00		11.30	
4TH AND STARK ST. (Tkt. Office)	.9	8.00	10.50	1.30	3.50	4.50	5.20	6.05	8.05	9.35	11.35
Fourth and Jefferson...	1.1	f 8.03	f10.53	f 1.34	f 3.53	f 4.53	f 5.23	f 6.08	f 8.08	f 9.38	f11.38
Bancroft....	2.7	f 8.09	f10.59	f 1.40	f 4.00	f 4.59	f 5.29	f 6.16	f 8.14	f 9.44	f11.44
Third and Miles Streets...	4.3	f 8.12	f11.02	f 1.42	f 4.03	f 5.01	f 5.31	f 6.18	f 8.16	f 9.46	f11.46
Bertha....	5.5	8.16	11.05	1.46	4.10	5.04	5.36	6.24	8.20	9.50	11.50
Dosch....	6.0	f 8.17	f11.06	f 1.47	f 4.11	f 5.05	f 5.37	f 6.25	f 8.21	f 9.51	f11.51
Pine....	6.5	f 8.18	f11.07	f 1.48	f 4.12	f 5.06	f 5.38	f 6.26	f 8.22	f 9.52	f11.52
Woodrow....	7.0	f 8.19	f11.08	f 1.49	f 4.13	f 5.07	f 5.39	f 6.27	f 8.23	f 9.53	f11.53
Shattuck....	7.6	f 8.22	f11.11	f 1.52	f 4.19	f 5.10	f 5.44	f 6.32	f 8.25	f 9.55	f11.55
Olsen....	7.9	f 8.23	f11.12	f 1.53	f 4.20	f 5.11	f 5.45	f 6.33	f 8.26	f 9.56	f11.56
Raleigh....	8.9	f 8.25	f11.14	f 1.55	f 4.22	f 5.13	f 5.47	f 6.36	f 8.28	f 9.58	f11.58
Arrow....	10.1	f....				f....	f....	f....	f....	f....	f....
Beaverton.	11.0	8.31	11.20	2.01	4.28	5.19	5.53	6.45	8.33	10.03	12.03
St. Mary's...	12.3	f 8.33	f11.22	f 2.03	f 4.31	f 5.22	f 5.56	f 6.47	f 8.35	f10.05	f12.05
Huber....	13.4	8.35	f11.25	f 2.06	f 4.34	f 5.24	5.58	6.49	f 8.37	f10.07	f12.07
Aloha....	14.0	8.37	f11.27	f 2.08	f 4.36	f 5.25	6.00	6.51	f 8.39	f10.09	f12.09
Tobias....	14.8	f				f...	f...	f...	f...	f...	f...
Reedville....	15.5	8 40	11.30	2.11	4.40	5.30	6.05	6.56	8.43	10.12	12.12
Witch Hazel....	16.9	f 8.42	f11.32	f 2.13	f 4.42		f 6.07	f 6.58		f10 14	f12.14
Hays....	17.3	f					f...				
Matson....	17.6	f 8.43	f11.34	f 2 15	f 4.43		f 6.08	f 6.59		f10.16	f12.16
Newton....	18.6	f.8.45	f11.36	f 2.17	f 4.45		f 6.10	f 7.01		f10.18	f12.18
Hillsboro, Ticket Office....	20.6	8 53	11.43	2.26	4.54	Dly.ExSun	6.18	7.10		10.25	12.25
Jobe....	22.8	f 9 01	f11.49	f 2.31	f 5.00		f 6.23	f 7.15			f12.30
Killgore....	23.7	f					f...				f...
Cornelius....	24.7	9 05	11.53	2.34	5.03		6.27	7.18			12.33
Catching....	25.6	..	f11.55	f 2.36	f 5.05		f 6.29	f 7.20			f12.35
Eddy (Masonic Home)....	26.1	f					f...				f...
Ar. FOREST GROVE Ticket Office	27.4	9 16	11.59	2.40	5.15		6.35	7.25			12.40

CORRECTED TO APRIL 4, 1926
Light Face A. M. Dark Face P. M.
Subject to Change Without Notice

†Daily Except Sunday

✦ Passengers for Tillamook branch transfer at Beaverton.
‡Connects with Tillamook Branch train at N. Range and Main Street Hillsboro for points as far as Cochran.

f Flag Stop. * Daily Trains stop at Flanders, Burnside and Morrison Streets, Portland, and flag at Hooker St., Portland; Archer; Hefter; Hays, Ware; 10th St., (City Park), 6th and Main, N. Range and Fir, Hillsboro; 3rd and 5th Sts. and 3rd Ave.; Forest Grove.
A-20 3-30-26 5M

This April 1926 timetable was issued in the year that the Southern Pacific began selling surplus rolling stock to the Pacific Electric in Los Angeles. Ten trains are still running on the West Side, but service reductions would soon see buses replace interurbans on some lines. The last electric train operated on October 5, 1929, after which track loops were quickly removed from Newberg, Hillsboro, and Forest Grove. (Courtesy Mark Moore.)

Red Electric No. 203 and mates were stored on a siding near Yamhill prior to going to California in 1936. A few trailers went to the Northwestern Pacific, but 28 surplus Red Electrics went to the Pacific Electric in 1928 and 1930 where they were dubbed "Portlands" and continued service through the 1930s. Some stayed behind to become cabooses, agent's quarters, bunkhouses, lunch cars, or sheds. (Courtesy Oregon Historical Society, OrHi 24794.)

76

The Willamette Falls Railway (WFR) began operating from Willamette to the Portland General Electric (PGE) powerhouse near West Linn in February 1894. In 1912, Portland Eugene and Easton (PE&E) bought the line and planned shops for the Red Electrics along the WFR right-of-way. By the 1920s, a fleet of four streetcars provided 60 trips per day over 3.9 miles on the southern portion of the line. A unique electric logging operation utilized the northern end. (Courtesy Mark Moore.)

Forest Grove had streetcars before the Southern Pacific's Red Electrics arrived in 1914. The Forest Grove Transportation Company was incorporated in 1906. Contemporary accounts indicate that a 1.7-mile street railway service operated through the south side of town until 1911. The small interurban in this *c.* 1908 view in downtown Forest Grove may have been an ex–Oregon Water Power (OWP) car from Portland. The car in this promotional photograph has been overprinted with the company name.

77

This map highlights the Portland Electric Power Company (PEPCO) interurban lines, including the Willamette Valley Southern Railway (WVS) line to an area just south of Molalla. By the time it was published in an April 1938 *Official Railway Guide*, the WVS was operating as a freight-only service between Oregon City and Kaylor. Until the route was cut back to Kaylor in 1930, passenger service had been available all the way from Portland (over PEPCO tracks) to Mount Angel. All operation on the WVS ceased six months after this map was issued.

Five

WILLAMETTE VALLEY SOUTHERN (1915–1933)

A group of local businessmen organized the Clackamas Southern Railway Company in 1911 to build a line from Oregon City as far south as Salem. The railway would be situated well to the east of competitors Oregon Electric and Southern Pacific through country not served by other railroads.

As construction finally got under way in January 1914, the railroad suffered financial setbacks and was reorganized as the Willamette Valley Southern Railway (WVS). That April, after railway president Grant Dimick tried unsuccessfully to obtain loans for a scaled back line terminating in Silverton, the WVS became a subsidiary of the Portland Railway Light and Power Company (PRL&P). The 31.9-mile route from Oregon City to Mount Angel opened on October 23, 1915. It would turn out to be the last interurban railway constructed in Oregon.

The WVS route through thinly settled farmland and forest was primarily designed for freight service. Passenger volume was minimal since through service was provided into Portland over PRL&P trackage, but the southern end of the line stopped short of a connection to central valley towns.

Although business was never very good on the Willamette Valley Southern, hopes picked up when two large lumber companies began increasing their timber shipments over the line in 1927. The nearly bankrupt railroad was encouraged to reorganize again, this time as the Willamette Valley Railway. Dreams faded after a large forest fire swept through local timberlands in September 1929. This setback was followed by the Great Depression.

In 1930, passenger service over the southern portion of the Willamette Valley Southern from Kaylor, just south of Molalla, to Mount Angel was discontinued. All passenger service was abandoned three years later, on April 9, 1933. Freight operation ceased on September 30, 1938, when the last timber had been removed from the forest fire salvage area. The WVS had sustained operating losses for all but one of its last eight years.

Semi-steel, arched-roof Willamette Valley Southern passenger motor No. 12 is seen here in a 1914 builder's photograph. The WVS roster included six passenger cars and one locomotive. Conflicting sources indicate that there were two combines (Nos. 1 and 2), one or two passenger motors (Nos. 3 and 11), and a trailer (No. 14). All are believed to have been built by the Niles Car Company of Cleveland, Ohio.

Dark red caboose No. 1450 is seen next to the station and substation at Monitor. This photograph's date is unknown, but judging from the condition of the attractive station, it is not the last years of operation. Monitor was one of four regular stations on the line. The others were at Oregon City, Beaver Creek, Molalla, and Mount Angel. No. 1450 was built from a boxcar by PRL&P before 1904.

This Willamette Valley Southern schedule from the June 15, 1915, official timetables shows four daily passenger trains in each direction between Oregon City and Mount Angel during the railroad's first year of operation. An hour-and-a-half was required for the 31.9 mile trip. There were 32 stations or flag stops. Trains ran from 7:25 a.m. until 8:00 p.m.

Willamette Valley Southern
Oregon City-Mt. Angel Service

Oregon City to Mt. Angel Trains Leave Daily					STATIONS		Mt. Angel to Oregon City Trains Lv. Daily			
READ DOWN							READ UP			
6	4	2	8	Mls	Lv.	Ar.	1	7	3	5
6.30	2.50	8.50	7.25	.0 Oregon City		8.30	10.30	2.30	6.25
6.33	2.53	8.53	7.28	.7 Kansas City		8.24	10.24	2.24	6.19
6.36	2.56	8.56	7.31	1.3 Collis		8.22	10.22	2.22	6.17
6.38	2.58	8.58	7.33	1.7 Campine		8.21	10.21	2.21	6.16
6.39	2.59	8.59	7.34	2.1 McBain		8.20	10.20	2.20	6.15
6.45	3.05	9.05	7.40	3.4 Maple Lane		8.15	10.15	2.15	6.10
6.46	3.06	9.06	7.41	3.8 Robbins		8.14	10.14	2.14	6.09
6.48	3.08	9.08	7.43	4.7 Glen Oak		8.12	10.12	2.12	6.07
6.49	3.09	9.09	7.44	5.3 Swift		8.11	10.11	2.11	6.06
6.53	3.13	9.13	7.48	6.9	S... Beaver Creek		8.07	10.07	2.07	6.02
6.57	3.17	9.17	7.52	8.4 Ingram		8.03	10.03	2.03	5.58
7.00	3.20	9.20	7.55	9.3 Spangler		7.59	10.00	2.00	5.55
7.02	3.22	9.22	7.57	9.7 Lewis		7.57	9.58	1.58	5.53
7.11	3.31	9.31	8.06	12.1 Buckner Creek		7.48	9.47	1.48	5.43
7.16	3.36	9.36	8.11	13.5 Howard		7.43	9.42	1.43	5.38
7.19	3.39	9.40	8.14	14.0 Mulino		7.41	9.40	1.41	5.36
7.22	3.42	9.43	8.17	15.9 North Liberal		7.38	9.38	1.38	5.33
7.24	3.44	9.44	8.19	16.5 Liberal		7.36	9.36	1.36	5.31
7.25	3.45	9.45	8.20	17.0 Huntley		7.35	9.35	1.35	5.30
7.27	3.47	9.47	8.22	18.2 Richard		7.33	9.33	1.33	5.28
7.30	3.50	9.50	8.25	19.2	S....... Molalla		7.30	9.30	1.30	5.25
7.33	3.53	9.53	8.28	20.5 Kayler		7.27	9.27	1.27	5.22
7.35	3.55	9.55	8.30	21.6 Ogle		7.25	9.25	1.25	5.20
7.37	3.57	9.57	8.32	22.6 Hitchman		7.23	9.23	1.23	5.18
7.40	4.00	10.00	8.35	24.1 Yoder		7.20	9.20	1.20	5.15
7.43	4.03	10.03	8.38	25.3 Busch		7.17	9.17	1.17	5.12
7.45	4.05	10.05	8.40	26.4 Wilda		7.15	9.15	1.15	5.10
7.47	4.07	10.07	8.42	26.9 Harding		7.13	9.13	1.13	5.08
7.51	4.11	10.11	8.46	28.4	S........ Monitor		7.09	9.09	1.09	5.04
7.54	4.14	10.14	8.49	29.7 Dominic		7.06	9.06	1.06	5.01
7.57	4.17	10.17	8.52	30.9 Berning		7.03	9.03	1.03	4.58
7.58	4.18	10.18	8.53	31.6 College		7.02	9.02	1.02	4.57
8.00	4.20	10.20	8.55	31.9 Mt. Angel		7.00	9.00	1.00	4.55

S.—Stops.
All other stations trains will stop upon flag only.
A. M. figures in light face. P. M. figures in black face.

The loop track at Mount Angel marked the southern terminus of the Willamette Valley Southern Railway. Mount Angel Station is seen in the center of this wet scene. A caboose is parked on the freight track next to the depot. Looming through the fog in the left background is St. Mary's Roman Catholic Church, which was built in 1912.

Willamette Valley Southern Railway Company

FORM R. T. 1 GOING COUPON

4435

FROM *Oreg City*

TO *Busch*

IF HAL FARE ½ PUNCH HERE

Good only on date stamped on back or one day following.

B. C. Punch

This 2¾-inch yellow WVS ticket for a trip from Oregon City to Busch was issued June 23, 1916. Busch was a flag stop seven miles north of Mount Angel. The words "Going Coupon" indicates that this was a one-way ticket. "B.C. punch here" may refer to Beaver Creek Station, which was one of two scheduled stops between Oregon City and Busch.

WVS combine No. 1 and trailer No. 14 stop for passengers at Spangler in 1915. Flag stops on the WVS had simple wooden waiting stations. Shiny No. 1 is resplendent in fancy trim. Caboose No. 1450, at right, is on the end of a short freight that has gone "in the hole" to wait for the passenger train.

The conductor leans out of the baggage door as Willamette Valley Southern train No. 4 pauses for the camera on Spangler Hill, 19 miles south of Oregon City, in 1923. The southbound two-car train is led by combination car No. 1. The surrounding countryside has not seen much development, a problem that plagued the WVS to the end.

Willamette Valley Railway passenger motor No. 11 is seen at Oregon City's Fourteenth and Main Streets terminal in the livery of later years, black with no trim. This view across the puddles was taken in the late 1920s after the Willamette Valley Southern Railway had been reorganized as the Willamette Valley Railway. Note the riveted-steel sides and colored-glass upper sash.

83

This view inside the cab of a Willamette Valley Southern passenger motor shows a unique three-point controller, as well as Westinghouse air brake controls and gauge. In view of the chipped and scratched paint, this picture likely was taken in later years. (Photograph taken by Fred L. Blaisdell.)

Willamette Valley Southern equipment was stored in PRL&P's Sellwood carbarn on Southeast Thirteenth Avenue and Ochoco Street. The car next to combine No. 1 is one of the ex–Mount Hood Railway and Power Company 1124–1127 series interurbans. Mount Hood Railway became part of PRL&P in 1912. The picture is not dated, but the 1124-class cars were retired in the mid-1930s.

Willamette Valley Southern electric locomotive, or "juice jack," No. 40 approaches the Beaver Creek Station with a short freight consisting of a log car, a boxcar, and a caboose. The train is heading south toward Mount Angel. The railroad's hopes for increased shipments of timber and farm produce were never realized. Note the dilapidated barn behind the substation and the water tower behind the locomotive.

No one appears to be in a hurry as a station agent and a hostler join the gloved motorman and conductors alongside Willamette Valley Southern No. 12 at Mount Angel in 1923. Mount Angel was the railroad's farthest extension south of Oregon City. The spire of St. Mary's Church can be seen behind the depot.

85

Car No. 12 is seen on the end of a two-car train at Oak Grove in 1928. During the 1920s, three daily trains ran in each direction between Oregon City and Portland. They were through trains and did not make stops in Portland while en route. The 13.2-mile trip took between 45 minutes and one hour depending on the time of day.

WVS freight locomotive 40 has stopped in front of an unidentified station c. 1933. The personnel atop the steeple cab appear to be a wrecking crew dismantling stations after the close of passenger service. No. 40 was a 50-ton steeple cab built by the American Locomotive Company (ALCO). After working on the Willamette Valley Southern, it became Oregon Electric No. 10. Note the large brass bell.

In January 1940, dilapidated trailer No. 14 awaits its fate after having been transferred to Cottage Grove. Two years had passed since the Willamette Valley Southern was abandoned, but it had been nearly seven years since the last passenger train ran over the rails from Oregon City. (Photograph taken by Randall V. Mills.)

Former WVS combine No. 2 is an electric ghost after years of use as a storeroom in the East Portland "bone yard." Only the elegant, colored-glass upper-sash windows hint at a more refined past. After the Willamette Valley Southern's demise, the car was renumbered as Portland Traction Company No. 1416. It was scrapped soon after this picture was taken, about 1952.

This map shows the Salem streetcar system at its height at the beginning of the 20th century. Over the years, competing railway companies built nearly a dozen streetcar lines and "trippers" (routes that turned back before reaching the end of the line), including Depot, State Prison, Asylum, Fairgrounds, State Street, Yew Park, Twelfth Street, South Commercial, and Salem Heights. Oregon's capital city had the most extensive system of the Willamette Valley towns. This map has been modified from one that first appeared in *The Southern Pacific in Oregon* by Ed Austin and Tom Dill. Red Electric and OE lines have been removed to better reveal city trolley routes. (Courtesy Ed Austin.)

Six

SALEM STREET RAILWAYS
(1889–1927)

The Salem Street Railway began operation on January 15, 1889, with a horsecar line that started on Commercial Street and proceeded east past the capitol to the railroad depot. Later that year, extensions were added to the Fairgrounds and East School.

Salem's street railway history includes a future U.S. president. During 1889–1891, Herbert Hoover occasionally worked for the horsecar company to earn money while going to school. He was 16 years old when he started working for the railway company. The future president was living with his uncle Dr. Henry Minthorn, who was chief executive of the railway.

On May 27, 1890, the rival Capital City Railway (CCR) brought electric streetcars to Salem. The CCR built lines to the penitentiary and the cemetery. A powerhouse and carbarn were constructed near State Street along North Mill Street. Extensions were made up Seventeenth Street to the fairgrounds in 1891, and from Asylum Avenue to Garden Road in 1899.

Salem had an over abundance of trolley routes by the 1890s, as lines were added to the Asylum, Yew Park, and Salem Heights. The economic downturn of the mid-1890s would bring receivership and consolidation. The Salem Street Railway was reorganized as the Salem Motor Railway in 1889 and began electrifying. In 1897, when debts could not be repaid, the company was sold at a receiver's sale.

In 1901, all lines were consolidated as the Salem Light, Power, and Traction Company. A quick succession of owners followed. On June 11, 1904, Denver interests incorporated the Citizen's Light and Traction Company. In June 1906, Citizen's became part of the Portland Railway Light and Power Company, which began renovating older Portland streetcars and transferring them to Salem. On May 5, 1912, the 13.8-mile system was sold to the Portland, Eugene, and Eastern Railway.

In 1920, four new Birney safety cars were added to the fleet, yet newer equipment was not enough to overcome a 30-year lack of profitability. Buses began replacing trolleys on some lines in 1924. Abandonment of streetcar service came on August 4, 1927.

Salem Street Railway horsecars Nos. 1 and 3 await passengers at the train station in 1889. Both the ornate depot and Salem's first streetcar line had just been completed. The route began on Commercial Street and ran to the depot and capitol via State and Twelfth Streets. The double-ended closed horsecars were built by Wight and Brownell of St. Louis, Missouri, and could accommodate 16 passengers. (Courtesy Ed Austin.)

Capital City Railway No. 2 rounds the corner in front of the A. N. Gilbert home at Liberty and Chemeketa Streets on the way to the insane asylum (later Oregon State Hospital) around 1892. Keller and Son's Furniture is behind the car. Expanding trolley lines brought development and suburbanization to Salem during the 1890s. (Courtesy Salem Oregon Public Library, Historic Photograph Collections.)

Salem's first two electric streetcars pause to have their image captured on the Asylum Line in a Cronise Studio photograph taken c. 1889. The motorman of Capital City Railway No. 2 has taken off a glove as he stands next to a track worker with a pick and shovel. (Courtesy Oregon Historical Society, OrHi 97992.)

A short four-wheel trolley towing an open trailer pauses in front of Capital Business College on the corner of Commercial and Court Streets as crowds watch a c. 1891 circus parade. Future president Herbert Hoover could well have been watching since he was attending the business school at the time.

91

Capital City Railway No. 30 rumbles past the Reed Opera House on the corner of Liberty and Court Streets in 1893. The short four-wheeler is European in appearance, with boxy enclosed platforms and a roof-mounted headlamp. The Reed Opera House was constructed in 1869–1870 by Gen. Cyrus A. Reed. (Courtesy Marion County Historical Society.)

This photoengraving shows two Capital City Railway cars passing in front of the Unitarian Church on the corner of Cottage and Chemeketa Streets c. 1894. Both trolleys show recent improvements in design. The open car is longer than the trailers used in horsecar days, and it features a clerestory—rather than Bombay—roof. The enclosed platforms on the other car are another innovation.

The vehicle resembling the cartoon "Toonerville Trolley" in this charming 1900 photograph is a three-windowed horsecar that had been converted into an electric. The scene is at the end of the line at Twelfth and Howard Streets in front of Prof. James Mathew's house. Two little girls are "taking the sun" in the foreground.

An open streetcar is westbound on State Street in a view taken after out-of-state interests took control of Salem's consolidated street railway system in 1904. Between 1906 and 1908, Citizen's Light and Traction Company (then owned by Portland Railway Light and Power) purchased four half-open California-style cars like this one from J. G. Brill. The old state capitol is visible in the background.

This picture of an empty streetcar on Commercial Street in downtown Salem was taken as a circuit court exhibit. A piece of tape attached to the original glass-plate negative reads, "Taken by Trover April 4, 1909 at 7:00 a.m." One wonders what took place on the little single-truck California streetcar. (Courtesy Oregon State Archives.)

A California car meets the train at the Southern Pacific depot in Salem on a rainy day c. 1909. The depot was originally the Oregon and California Railroad station. The large sign on the dash may look like a route number, but it is an advertisement reading, "Monday, May 4th Norris & Rowe Circus." Salem streetcar routes were named after their destinations. (Courtesy Mark Moore.)

No. 4 is waiting near the train station on the Fairgrounds Line in the years when trolleys flaunted fancy paintwork and trim. The boys on board appear to be wearing uniforms, so they may have come from a ballgame. Cable car–like No. 4 was built by Brill and arrived in 1906. It was remodeled seven years later as a Portland Eugene and Eastern overhead-line repair car. (Courtesy Mark Moore.)

This bird's-eye view looking west from the capitol shows a cluster of important buildings, including the post office (built in 1903), Marion County Courthouse (built in 1885), and the First Methodist church (built in 1872). A former Portland interurban car now in city service is seen passing on State Street at the far left. The former post office building was moved onto the Willamette University Campus and is still there today.

In Salem, one could ride a trolley to the penitentiary. Trolley No. 22 is seen around 1905 traveling along a pleasant, tree-lined portion of the State Prison Line, which ran northward out State Street. A young lady newly arrived in town wrote home praising the transportation system by saying, "Street cars in Salem take you to the asylum, penitentiary and the cemetery."

No. 52 was built by the Hand Manufacturing Company of Portland in 1893. A handful of Hand cars were among the surplus group that were overhauled by PRL&P and sent to Salem to replace the antiquated trolleys then in use. They went into service at the end of 1907 and continued in use through the Portland Eugene and Eastern buyout in 1912.

No. 75 was a four-wheeler built for Salem. The builder's sign is largely unreadable but looks to be for the short-lived Danville Car Company of Danville, Illinois, which was acquired by J. G. Brill in 1908. The car reflects the standard Brill design, including arched windows, curved sides, folding doors, and a clerestory roof. The small windows on the roof could be opened to improve ventilation.

The crew of Asylum Avenue car No. 36 poses in front of the recreation hall for Catholic youth activities on Center Street. The towered brick structure in the background is Sacred Heart Academy, an all-girls high school that opened in 1873 on the east side of Cottage Street between Chemeketa and Center Streets. The parish house is next door.

Salem had a diversity of street railway rolling stock. No. 20 looks like a miniature interurban. It features five-window ends typical of the Holman Car Company of San Francisco, yet it is a short, single-truck car. The young conductor is wearing a double-breasted, wide-lapelled uniform jacket and high hat. The metal box next to his arm is the socket for a removable headlamp.

"Little Jack" poses with ex–Portland Railway Light and Power No. 1039 around 1907. A number of older cars were refurbished for use in Salem. Although not the new trolleys riders were hoping for, they were an improvement. No. 54 was one of three interurbans originally used on the Mount Scott and Hawthorne Avenue lines in Portland. They were built by the Northern Car Company in the mid-1890s.

Trolley No. 56 is on Commercial Street on the Salem Heights–South Commercial run during the 1910s. No. 56 is thought to have been built by W. L. Holman in 1894 for Portland. An advertisement for motorcycle races is fastened to the safety fender. The writing on the top of the print reads: "Defendants Exhibit #5," which means that this is another court record. (Courtesy Oregon State Archives.)

Car No. 40 is at the outer terminus of the State Street Line in this undated photograph. It is a four-wheel closed motor with a single trolley pole and enclosed platforms. The conductor is standing on the plank sidewalk, and the motorman is on the lowest step holding the controller handle in a gloved hand.

Children are posing on the platform of Salem Street Railway No. 861. Originally No. 70, the car was renumbered when the Southern Pacific took over Salem operations in 1912 and painted it in a simple dark livery with no trim. It was rebuilt with the larger vestibules seen here in 1916. The car is thought to have been a 1909 product of the Danville Car Company.

A Salem streetcar is westbound on State Street in 1918. Buildings in view, from left to right, are the Masonic Temple, Marion County Courthouse, the post office, and the old capitol. Compare this to the view taken from the opposite direction on page 95. The streetcar is a standard Brill double-truck semi-convertible.

Salem Street Railway No. 863 has been caught in the blizzard of 1919. The capitol building in the background was destroyed by fire on April 25, 1935. It was built in 1876. No. 863 was a product of the Danville Car Company and arrived in Salem in 1909. It was remodeled for a PAYE (pay as you enter) configuration in 1916 and was retired six months before the end of service in 1927.

Salem's last streetcar is changing ends in the downtown business district in 1927. With the purchase of Birney cars Nos. 880–883 in 1920, Salem could boast of the newest trolleys in the Willamette Valley. Birneys were an economical single-truck trolley that was popular with management because they could be safely operated by a single person acting as both motorman and conductor. (Courtesy Marion County Historical Society.)

RAIL MAP of ALBANY, OREGON

This 1910s rail map of Albany shows streetcar, railroad, and interurban tracks through the Hub City. The Southern Pacific and Corvallis and Eastern railroad lines are shown, as is the trackage of the Oregon Electric Railway (discussed elsewhere in this book). The Albany Street Railway operated a single electric streetcar line from the train station to First Avenue and Washington Streets between 1909 and 1918. The route of the earlier steam dummy line to the Sunrise District to the south and east of the depot is not shown. The short curved spur track to the left of the train station was for the original horsecar carbarn.

Seven

ALBANY STREET RAILWAYS (1889–1918)

The initial run over Albany's first street railway was made on August 30, 1889. Revenue service commenced a few days later over a 1-mile horsecar line that ran from the SP depot downtown via Lyon Street, and then proceeded west to the St. Charles Hotel at First Avenue and Washington Streets. The car was manufactured by A. J. Anslyn of Albany and used Albany Iron Works wheels. At 12 feet, it was 6 inches longer than cars on the Morrison line in Portland.

By 1892, a steam dummy engine named Goltra Park was pulling former horsecar No. 1, and Albany had joined the era of mechanized mass transit. It was just in time to accommodate a new extension to the orphan home one-half mile south of the depot in the Sunrise District. The extension was withdrawn with the cessation of steam motor service.

By 1900, Goltra Park had fallen into disrepair, and Albany suffered the distinction of being downgraded to a mainly horsecar operation again. A white horse named "Old Charlie" now pulled the car. By 1903, as ridership increased, two horses were needed to pull a larger coach, and a small steam locomotive sometimes replaced the horses.

On December 31, 1908, the Portland Eugene and Eastern Railway (PE&E) purchased the Albany Street Railway Company and began plans for electrification. PE&E obtained a franchise to operate an electric street railway in nearby Corvallis at the same time. That plan was dropped, however, and the Corvallis Street Railway never moved beyond a 2-mile horsecar system developed in the 1890s.

In 1909, two trolleys served Albany's single route. For the next 10 years, one to two cars were rotated to Albany from the PE&E's Salem and Eugene operations. Although there had been a carbarn during the horsecar days, the Albany system was later described as having no barn.

The trolley era in the Hub City was over in less than a decade. In 1918, Albany became the first Willamette Valley city to abandon streetcars. At least the city could lay claim to having inaugurated the valley's first motorized (steam dummy) street railway.

Albany's first mechanized streetcar was a steam dummy pulling a four-wheel trailer. Steam dummies were small tank engines enclosed in streetcar-like bodies in order to hide hissing steam and whirling connecting rods from passing horses. Motor No. 3 Goltra Park is said to have been owned by the Goltra family. It made the rounds downtown, back to the depot, and then out to the Sunrise District. (Courtesy Robert Potts.)

Albany's other street railway locomotive and coach are awaiting passengers in front of the St. Charles Hotel at First and Washington Streets c. 1900. The locomotive was a 0-4-2T tank engine with four small driving wheels. Engines of this type, called "dinkies," carried an onboard water supply and did not require tenders. The locomotive is thought to have been built by H. K. Porter c. 1882. (Courtesy Robert Potts.)

Albany's first streetcar wends its way slowly into the muddy intersection in front of the St. Charles Hotel. The hotel is surrounded by a diversity of vehicles, including an omnibus-style stage, an elegant private carriage, and a two-horse dray. Two couples are observing the mélange from the hotel balcony. A large arc lamp hangs above the intersection.

The Albany Street Railway carbarn is seen at the left in this early-1890s view taken from the Southern Pacific depot. A horsecar is parked on the spur next to the barn. Since this was before electric streetcars arrived, there are no wires over the tracks, which lead from the station toward Lyon Street. In the background is the original St. Mary's Catholic Church. (Courtesy Albany Regional Museum.)

A horsecar sits at the end of the line in front of the original Oregon and California depot and hotel. The current station was built nearby in 1908, and the old one was relocated one block away on Lyon Street near Ninth Avenue. It survived as the Depot Hotel until the late 1930s. The man at the left is standing in front of a popcorn machine. (Courtesy Albany Regional Museum.)

A crowd had their picture taken for posterity in 1909 when horsecar No. 1 and its driver Mr. Ross made their last journey. The location is Second and Lyon Streets in front of the Albany Fire Hall. The building in the background is the office of Dr. Cleek, a dentist. There are 30 male celebrants on the roof, platforms, or hanging out the windows of the slightly overloaded car.

A banner on trolley No. 3 heralds the first day of electric operation in 1909. The single word "Albany" indicates that the operation is now one of several Portland Eugene and Eastern Railway divisions. The crowd of dignitaries and their families gathered around the new-fangled motorcar included Fred Nutting, publisher of the *Albany Democrat* newspaper. (Courtesy Albany Regional Museum.)

As the 20th century dawned, every town desired a street-scene postcard featuring the latest in transportation. As with most such cards, this 1909 scene is carefully posed. The motorman on trolley No. 3 is ringing the bell as he makes his way down a First Street clogged with buggies, delivery wagons, bicycles, and horseless carriages.

ELKS TEMPLE, ALBANY, ORE.

The crew looks toward the camera as No. 3 rounds the corner in front of the Elks Temple on Lyon Street. The building next door has been restored and today houses the law firm of Weatherford, Thompson, and Cowgill. The author's father, Orval N. Thompson, practiced law here for 54 years. He was also an Elks Exalted Ruler and a member of both houses of the Oregon legislature. (Courtesy Oregon Historical Society, OrHi 182.)

A parade on First Avenue at Broadway moves over for streetcar No. 1 in the summer of 1909. It is probably the Fourth of July since buildings are decorated with patriotic bunting and strings of lights. Automobiles carrying an official court are covered in flowers and flags. A banner promotes the Albany Chautauqua, and a sign on the trolley advises people to "Take this car to the ball game."

Streetcar No. 3 is passing the Elks Temple on Lyon Street in the first years of trolley operation. Elks Lodge No. 359 survived two fires before a third one finally destroyed it in 1979. In later years, the ornate towers were removed. The street level was occupied by many businesses, including Sternberg's clothing store, a frequent advertiser on the streetcars.

Albany's most photographed streetcar (No. 3) is seen moving eastward, away from the camera, on First Avenue at Ferry Street c. 1912. The banner across the street is for I.O.O.F. (Odd Fellows) Lodge No. 4. The Burkhart and Lee drugstore is festooned with billboards advertising Pure Drugs and Owl cigars. Across the street is Davenports Music Store. Note the many towered Victorian buildings on First Street.

Both of Albany's streetcars have stopped for a portrait in front of the Revere House on First Avenue and Ellsworth Street c. 1910. The Magnolia Mill, which was built by Thomas Monteith in 1851, can be seen in the right background. Trolleys Nos. 1 and 3 were built by J. G. Brill in 1906 and 1907, respectively. Although lettered for PE&E, Albany Division, they were sometimes shared with Salem and Eugene.

This c. 1916 scene looks south on Lyon Street near First Avenue. The building in the center is the Hotel Hammel, which was built in 1915 and later renamed the Hotel Albany. The 1887 vintage S. E. Young Building at right was moved from First Avenue and Broadalbin Street in 1912. It now houses the Albany Regional Museum, which helped in the preparation of this book.

One of Albany's two trolleys is turning the corner at First Avenue and Lyon Street in front of the Elks Temple on a rainy day c. 1916. This area was close to Albany's Chinatown. The Saito Japanese Café was located in front of the woman crossing the street, and Chin's White House Restaurant is located at the far right. (Courtesy Albany Regional Museum.)

Trolley No. 70 is moving away from the SP depot toward Lyon Street. The curved spur to the left once led to the old horsecar barn. In front of the streetcar is the two-story Depot Hotel. The man crossing the street is approaching the barbershop between the hotel and Rohrbough's lunch counter. No. 70 was built by the Danville Car Company c. 1909.

The trolley meeting the train at the Southern Pacific Station in this undated postcard was originally a California-type car with open sections at each end and a closed center. The long running boards and grab handles remain, but the car has now been entirely enclosed. This was one of three streetcars, Nos. 76–78, that arrived from the Pacific Electric Railway in Los Angeles in 1912.

"Transfer" Station (point where 11th crosses UPRR today, was SPRR)

Key
- Fairmount (1907) 5.6 mi.
- College Crest (1910) 6.2 mi.
- Springfield (1910) 4.8 mi.
- Blair (1912) 2 mi.
- 11th St. Extension (c. 1912)
- Oregon Electric Interurban
- Southern Pacific R.R.

EUGENE
Railroad & Streetcar Lines
Superimposed over 1979 street map

This map of railroad and streetcar lines in Eugene shows the Eugene street railway system at its peak in 1912. There are four trolley lines plus the Eleventh Street extension. The Oregon Electric Railway route into town from Albany is also in evidence, as are the Southern Pacific's steam railroad lines. The SP had intended to electrify the line from Corvallis, thus extending the Red Electrics service to Eugene, but that extension was never completed. This map has been modified from one that first appeared in *The Southern Pacific in Oregon* by Ed Austin and Tom Dill. (Courtesy Ed Austin.)

Eight
EUGENE STREET RAILWAYS
(1891–1927)

Henry Holden's Eugene Street Railway cars began operation on June 26, 1891. His mule-drawn streetcars ran from the Southern Pacific depot to the University of Oregon via Willamette Street and Eleventh Avenue. Two additional lines were planned, but the enterprise was unsuccessful, and the rails were gone from city streets after 1903.

By 1907, a number of plans had been put forth for an electric street railway in Eugene. Alvadore Welch, an electrical engineer from Portland, got the job done. On May 27, 1907, his Eugene and Eastern Railway took over construction, and on September 26, 1907, electric streetcars began running from the depot to the university. Two months later, the railway was ambitiously renamed the Portland Eugene and Eastern. The initial plan was to build an interurban that would challenge Southern Pacific's dominance.

Eugene's 18 miles of streetcar lines included the Blair, College Crest, Fairmount, and Springfield lines. The longest was the 4.8-mile route between Eugene and Springfield, which was completed on October 22, 1910. In 1912, the 2-mile-long line along Eighth, Blair, and River Road, became the last addition to what has been described as the greatest small-city streetcar system in the United States. A planned extension to the suburban community of Santa Clara northeast of Eugene was not built.

Eugene's trolleys were kept in a two-track carbarn on Thirteenth Avenue between Agate and Beech Streets. At its peak, a crew of 27 conductors, motormen, and shop workers kept a fleet of nine cars running from 6:00 a.m. until midnight each day. Twenty-minute headways were maintained during peak hours.

In 1915, Southern Pacific ownership of the PE&E was finalized, and things looked promising. Twenty years later, Eugene's trolley car era came to a close. In 1926, the Springfield line was the first to be converted to bus operation. The last trolley in Eugene ran on October 15, 1927.

Driver Wiley Griffin poses with Eugene Street Railway No. 4, which he drove from Willamette Street to the University District via Eleventh Avenue. Although this *c.* 1893 image is blurry, it is obvious that the area near the University of Oregon was still rural in nature, with pastures, barns, and neatly fenced homes. Wiley was one of Eugene's first African American residents. (Courtesy Lane County Historical Museum.)

In 1903, all traces of Eugene's pioneering mule-drawn streetcars disappeared when an ambitious mine operator removed rails from the streets for use in his mine. Four years later, Alvadore Welch completed a new electric streetcar system. Open cross-bench car No. 4 was ordered from J. G. Brill in 1906. The 72-passenger trolley was converted into line repair car No. 0202 in 1913. It wrecked in March 1921.

Willamette Street, Eugene's Principal Business Thoroughfare—Paved, 1907.

Eugene is making great preparations for the Oregon State C. E. Convention, Feb. 20-23 PLAN TO COME

A PE&E Brill streetcar is southbound on Willamette Street in this advertising card mailed on February 1, 1908. Though the street is newly paved, no automobiles are in sight. The card promotes a Christian convention to be held later that month. Along the side of the card a student named Clarence tells his mother that he has passed his Latin exams but that "the heavy ones" are yet to come. (Courtesy Mark Moore.)

Inbound trolley No. 10 is passing the new Eugene post office on Willamette Street in this c. 1910 scene. In 1937, a new post office next door replaced the 1909 facility. The 1937 post office is still in use today. The three-story building in the background is the Hampton Building, built around 1910. It was replaced by the Hult Performing Arts Center in 1982. (Courtesy Gholston Collection.)

117

Streetcar No. 9 is ready to start on the Fairmount run in this picture taken on Willamette Street near the Southern Pacific Railroad depot c. 1909. The turreted Victorian house on Skinner Butte in the background is the Shelton-McMurphey residence, which has enjoyed a view overlooking the city of Eugene since 1888. The large "O" on the butte is for the University of Oregon. (Courtesy Lane County Historical Museum.)

The nearly 5-mile extension from Eugene to Springfield went into service September 22, 1910, with much fanfare. The location is Third and Main Streets in Springfield, where the shrieking of mill whistles welcomed trolleys decked out in flags and bunting. To handle the crowds, a semi-convertible streetcar is pulling an open trailer. Both cars were likely J. G. Brill products. (Courtesy Lane County Historical Museum.)

The Springfield line appears to still be under construction in this c. 1910 scene looking east on Main Street in Springfield. A tower car is at work in the background, and a portion of the street has been dug up. The sign on the trolley advertises, "Base Ball Today at Kincaid Field." The building to the left is identified as "Hampton's Dry goods store."

PE&E No. 3 pauses on Willamette Street near the intersection with Ninth Avenue to pick up passengers around 1910. The Brill trolley is southbound on the newly completed Springfield Line. No. 3 was rebuilt to a one-man PAYE configuration in April 1916. It was retired in dilapidated condition at the close of Eugene operations. This car was sometimes used in Albany. (Courtesy Lane County Historical Museum.)

The gang is all here as PE&E trolleys Nos. 2, 4, 1, and 3 pose in front of the two-bay carbarn on Thirteenth Avenue between Agate and Beech Streets c. 1910. Streetcars Nos. 2 and 3 are in revenue service, while the other two cars are waiting on the ladder tracks. All four cars were built between 1906 and 1907 by the J. G. Brill Company of Philadelphia, America's leading streetcar

and interurban builder between 1868 and 1956. They were rebuilt for one-man operation in 1916. All but open car No. 4 survived until the close of streetcar service in Eugene in 1927. The destination sign on the dash of No. 1 is for the West Springfield run. (Courtesy Lane County Historical Museum.)

Well-patronized open "breezer" No. 4 is traversing the rolling hills of South Eugene on the College Crest line about 1904. Not a house can be seen in this bucolic scene, yet a businessman on the running board seems about to alight. No. 4, which was originally a trailer, was only a year or two from retirement when this picture was taken. (Courtesy Lane County Historical Museum.)

Three PE&E streetcars await passengers at the hotel across from the Southern Pacific depot on the north end of Willamette Street c. 1910. The occasion is unknown, but large crowds have gathered in front of the train station. No. 1 is on the Fairmount line, while No. 3 is signed for the cemetery and university on the Fairmount line. (Courtesy Mark Moore.)

One of Eugene's California-style streetcars, with both open and closed sections, pauses to let passenger Andrew Edblom disembark next to his residence on West Eighteenth Avenue (now West Seventeenth Avenue) near Friendly Street c. 1915. Edblom's sons and other family members can be seen near the three-story Craftsman-style house. PE&E purchased five California cars from Pacific Electric in 1912. (Courtesy Lane County Historical Museum.)

Conductor Tom Bradley and his gloved motorman pose with PE&E No. 3 at the Willamette Street terminus around 1912. Clearly seen in this close-up view are Brill type 27 trucks, safety fender, open clerestory windows, and the strap and socket for a removable headlamp. Eugene streetcars did not use trolley retrievers, so the rope hangs slack over the dash. (Courtesy Lane County Historical Museum.)

The crew of Fairmount car No. 9 strikes a pose near an unidentified brick building *c.* 1912. In addition to all those passengers leaning out the open windows, the car appears to have an extra conductor and an official. "P.E.& E. Ry.Co" was written above the middle window rather than across the curved lower side panel. (Courtesy Lane County Historical Museum.)

Two Fairmount streetcars pass on Eleventh Avenue near Hilyard Street on this undated postcard. At this time, Eleventh Avenue was a residential street lined with many fine Victorian homes. (Courtesy Lane County Historical Museum.)

A Fairmount trolley is approaching the tight radius curve on Alder Street at Thirteenth Avenue around 1912. The Patterson School is on the left. The turreted home in the background is the residence of Eugene Bible University president Eugene C. Sanderson. The three-story stone university building behind it later became Northwest Christian College. (Courtesy Lane County Historical Museum.)

The crew of two trolley cars is watching the birdie in front of PE&E No. 10 on an unidentified Eugene street (possibly Willamette) c. 1914. The car carries a "Eugene" dash sign, so it is inbound. Commercial buildings line the dirt avenue in the background, and globed streetlights can be seen among the trees on the right. (Courtesy Lane County Historical Museum.)

Fairmount car No. 867 is seen near the SP station with Skinner Butte and boxcars in the background. Four one-man, semi-convertible, arched-roof cars like this were built by the American Car Company of St. Louis, Missouri, in 1914. Eugene's newest trolleys featured wooden bodies on metal frames and type 39-E maximum-traction trucks. (Courtesy Lane County Historical Museum.)

The crew of trolley No. 3 has changed ends for the return trip to the SP station c. 1915. The unidentified location is at the end of a line with tracks stopping in front of a pasture. Motorman Tom Bradley has just moved the controller handle and key from the other end of the car, and conductor Walt Head is filling out a trip report (Courtesy Lane County Historical Museum.)

At first glance a railway enthusiast might think this 1915 view of PE&E cars Nos. 11 and 12 on Willamette Street had been taken in Los Angeles. In fact, these California-style cars with the distinctive Huntington five-window ends were purchased from its sister Pacific Electric in 1912. They continued in service in both Salem and Eugene until March 1927. Both were built by the St. Louis Car Company. (Courtesy Gholston Collection.)

The southbound streetcar stopping for a passenger on Willamette Street at Ninth Avenue reflects its 1916 rebuilding into a one-man, pre-payment (PAYE) configuration. Dual roll signs in the near-side window read, "To the Univ of Ore" and "Fairmount." Laraway's music and piano store is on the left in this *c.* 1920 picture. (Courtesy Lane County Historical Museum.)

ACROSS AMERICA, PEOPLE ARE DISCOVERING
SOMETHING WONDERFUL. THEIR HERITAGE.

Arcadia Publishing is the leading local history publisher in the United States. With more than 4,000 titles in print and hundreds of new titles released every year, Arcadia has extensive specialized experience chronicling the history of communities and celebrating America's hidden stories, bringing to life the people, places, and events from the past. To discover the history of other communities across the nation, please visit:

www.arcadiapublishing.com

Customized search tools allow you to find regional history books about the town where you grew up, the cities where your friends and family live, the town where your parents met, or even that retirement spot you've been dreaming about.